Who's Afraid of
Middle English?

Also by Dolores Cullen

CHAUCER'S HOST—UP-SO-DOUN

PILGRIM CHAUCER—CENTER STAGE

CHAUCER'S PILGRIMS—THE ALLEGORY

Who's Afraid of Middle English?

A Booke of Lystes

Dolores L. Cullen

2002 · Fithian Press, Santa Barbara, California

Published by Fithian Press
A division of Daniel and Daniel, Publishers, Inc.
Post Office Box 1525
Santa Barbara, CA 93102
www.danielpublishing.com

LIBRARY OF CONGRESS CATALOGING-IN-PUBLICATION DATA
Cullen, Dolores L., (date)
Who's afraid of Middle English / by Dolores L. Cullen.
p. cm.
ISBN 1-56474-401-9 (pbk. : alk. paper)
1. English language—Middle English, 1100–1500—Readers.
2. Titles of motion pictures. 3. Titles of books. 4. Quotations. I. Title.
PE537 .C85 2002
427'.02—dc21
2002000495

To Geoffrey Chaucer

for all he means to me
and all he means to the world

Contents

V. Newe Games with Oold Wordes

VI. Foode: the Centre of Eche Day

The Twenti Thyrde Psalm

Acknowledgements

The resources for this volume are the always essential *Concordance to the Complete Works of Geoffrey Chaucer* by Tatlock and Kennedy; the stalwart *Oxford English Dictionary*; the grimly-detailed "doctor's handbook" by Guy de Chauliac (1368); the marvel just completed, *The Middle English Dictionary* out of the University of Michigan at Ann Arbor; a nod to Dr. Seuss, whose Grinch name sounds very much like it was influenced by the medieval word *grinchen* which means "to gnash (one's teeth)"; family and friends, for suggestions of phrases to include; and the San Dimas Writers Group for their support and participation in all my endeavors.

The obstacle to instant understanding does exist, and I have no intention of belittling it. But I should like to say with emphasis...that it seems more formidable than it is. A bare fraction of time which we spend in learning to read Homer or Virgil or Dante or Molière or Goethe will enable us to read Chaucer as he is meant to be read, to wit, with delight.... For it is in words and idioms...Chaucer's men and women speak—speak, at their best, with a raciness and point and flavour that have never been surpassed. Nor is it [essential]—and I think I know—to master all the complexities of Middle English in order to follow with intelligence.

—John Livingston Lowes, *Geoffrey Chaucer*

Introduction

I've always found reading Middle English like playing a game. Many of the words are very understandable, especially if you've been conditioned by reading letters from folks you love dearly, but who never bother with standard spelling. Reading the words out loud helps a lot.

Reading aloud doesn't do the whole job when studying a medieval text. You'll need a dictionary, of course, as you do with any specialized reading. We are so fortunate to have the *Middle English Dictionary*, which has just been completed. It took more than fifty years to produce this phenomenon, an incomparable treasure for literature before 1500.

For this little volume you are holding, however, you won't need anything but your willingness to play the game, and your own common sense. The ever present but seemingly insignificant words—the, with, of, is, that—are exactly what we use today; they don't have to be learned as a foreign language would demand.

Beginning with the prayer on page 17, all the words you'll see are Middle English. If you find words with modern spelling, it's not because I overlooked them. It's because the spelling hasn't changed.

Once in a while a "similar" medieval term is substituted where the more modern form has not yet entered the vocabulary—like "kitoun" (kitten) replacing "pussy" in the nursery rhymes. One last admission: in a few instances you'll find a surprise; this is the signal (!). I couldn't resist including some powerful words that the Middle Ages used, but not in the way science, for example, uses them today.

You'll notice that in the prayers the letters U and V are inter-changeable. That's why, as a carry-over even today, when two Vs are printed side by side "VV" we call it a double U !

The two versions are a blend from several sources. The Lord's Prayer was not standardized—you couldn't hear a resonating recita-tion in unison at a church service. You'll also notice it takes several words to communicate "daily." "Daily" was first used in print in the fifteenth century, but not in a rendering of the prayer.

You're on your own now. Enjoy your Middle English adventure.

Version One

Oure Fader that art in heuyn
Halwed be thy name.
Thi kyngdome come to us
Thi wylle be don in erthe here
As hyt ys in heuene.
Our eche day bred gyf vs to day
And forgyue vs owre trespas
Als we do hem that trespas vs
And lede vs nat in temptacioun
But schelde vs alle from euel thynge.
Amen.

Version Two

Our Fadyr that art in heuene
Halowed by thi name.
Thy kyngdom be for to come
Be thy wille don as yt ys don in hevyn.
Our vche dayes bred yeue vs thys same day.
Foryeue vs our dettys as we do to oure detours.
And lede vs in-to no temptacioun
But we pray delyueraunce fro al wicked thinge.
Amen.

Who's Afraid of
Middle English?

I. Diverse Recreaciouns

Mocioun Pictoures

Affrican Quene
Wer-wolf of Londoun
From Russye Wyth Love
Aprill in Parys
Nexte Stoppe, Grenewych Village
Romayn Haliday
Visyte to a Smal Planet
Slowe Daunsynge in the Byg City
First Mone-dai in Octobre
The Dritti Dozeyne
Four Hors-men of the Apocalipse
The Odde Couple
Sory, Wrong Nomber
The Seventhe Seel
Two Wey Strecche
Thridde Fynger, Lefthande
The Eie of the Nedle
Shette My Mowthe
Streight Thurgh the Herte
Belle, Bok and Candel
The Exorcist
House of Wex
I Married a Wicche
No-thing Sacred
Thescape to Wytche Montayne
Tombe of the Lyvynge Deyde
Strange Voyses

Cat on a Hot Tin Rof
Chiken Everi Son-dai
Daunces With Wolfes
Elefaunt Boie
Fader Goos
The Lioun in Wynter
Buterflies Are Fre
Planet of the Apes
Silence of the Lombs
Shark!
Francis, the Talkynge Mule
What Is Up, Tygre Lilye?
Spither Womman Strykes Bak
A Fisshe Called Wanda
His Gyrle Fri-dai
The Boy on the Delphyn
Hors Fethres
Techeres
Ther is a Girle in Myn Soupe
The Mouce that Rored
A Man for Al Sesounes
Keies of the Kyngdom
Pokette Fulle of Myracles
The Rosarie Mordres
The Sacrifyse
Deliverance
Resurreccioun
Sworn to Silence
Sygne of the Crosse

The Ten Comandements

Tendre Mercies

Blak Narcisus

Redde Garters

On Golden Ponde

She Wered a Yelwe Riband

Rede Bagge of Corage

So Prowdly We Hayl!

Kysse and Telle

Luve Among the Ruines

Love With a Propre Straunger

Pyllow Talke

Slepinge Wyth the Enemi

Trewe Confessiounes

An Affaire to Remembre

Passioun Floure

The Oldeste Professioun

The Agonie and the Extasie

Gesse Who Is Cominge to Soper

Olyver!

Itte Is a Wonderful Lyf

Separate Tables

The Milky Wey

No Sadde Songes for Me

Outrageous!

A Smal Cercle of Freendes

Surrendre

The Sting

Over-borde

Sater-dai Nighte Fever

The Wisard of Oz

Fantasia

Rynge of Brighte Watir

Starre Werres

Brokene Arowe

The Strangler

Imitacioun of Lif

The Naked and the Ded

Robbours Rooste

Suspecioun

The Webbe

Renninge on Empti

Venym

Writen on the Wynde

Stoone Colde Ded

No-wher for to Hyde

Vengeaunce

Repe the Wilde Wynde

Terrour Binethe the Se

Sterre Chambre

Rere Wyndowe

Poysoun Ivy

Rebel Withouten a Cause

Straunge Brew

Rewthelees

Holwe Triumphe

The Olde Curiousite Shoppe

Queste for Fyr

The Serche

Oure Vynes Have Tendre Grapes

Perils of Pauline

Retourne from the Asshes

Ordinarie Peple

Whistlynge in the Derke

Sande Pibeles

The Huksters

The Croked-bakke Man of Notre
Dame

Ich Never Promised You a Rose
Gardin

Oon Flewe Over the Cuckowes Nest

If It Is Tewes-dai, This Mot Be
Flaundres

In the Theatre

Student Prince

Wondyrful Towne

Face the Musyk

No, No, Nanette

Milk and Hony

Noughti Marietta

At Hom Abrode

Forboden Melodie

Belles Are Ringinge

Bitterswete

The Desert Song

Greesse

Songe of Norwey

Cattes

Hyer and Hyer

Caunterbury Tales

Fre and Esy

Enchaunted Cotage

Grete Whyte Hope

Merye Widewe

Bare-foot in the Park

Myracle Werker

Of Myce and Men

Oon Touch of Venus

Badde Seede

Requiem for a Nonne

Come Bakke, Litel Sheba

Swete Brid of Youthe

Fleyinge Coloures

Folowe Mee

Same Time Nexte Yeer

Ever Grene

Syngynge in the Reyne

As Thousandes Chere

Sweete Charitee

Taak a Geaunt Steppe

Fade Oute—Fade Inne

Taak Hir, She Is Myne

The Fortune Teller

Blossom Tyme

A Taste of Hony

Tyme of Your Lyf

Wacche on the Rine

Bloo Mondai

Tribute

Up in Centre Park

Vewe Fro the Brigge

Wayte Until Derke

Brighte Eyes

What Pris Glorie?

Holde Every Thing!

Downe in the Valeye

Ich Remembre Modir

Whales of August

The Male Animal

Dairie Maydes

Innocent Eyes

West Syde Storie

Centurie Gerl

Hous of Floures

I Maried an Aungel

Grene Wilowe

Vagabond Kynge

Wissh Youe Were Heere

The Cat and the Fithele

Enemy of the Peple

Ne Sang I Never for Myn Fader

Riche Man, Poure Man

My Sustir Eileen

Old Acqueintance

On Moone Light Bay

By Juppiter!

Over Oon-and-Twenty

The Pirate

O Capitayn!

The Erl and the Gerl

Blewe Paradys

Onys Upon a Matres

Jubilee

The Cradel Wil Rokke

The Idoles Eye

Plesures and Paleises

A Reysyn in the Sonne

Rope

The King and Y

Pardoun My Englisshe

On Youre Toos

Ryver Wynde

Promises, Promisses

Calle Me Madame

Wilde Flour

Strete Scena

Cacche My Soule

This is the Armee

Tumble Inne

The Laughynge Husbonde

Musik Hath Charmes

The Consul

Take Mee Alonge

By the Beuteful See

Cacche a Sterre

Holde On to Youre Hattes

Stepping Stonys

Handes Uppe!

Caban in the Skie

Derest Enemi

Syttynge Prety

I do! I do!

Aungel in the Wynges

Into the Wodes

Any Persone Canne Whistle

Applause

Lytel Mary Sonne Shine

Singen Oute the Newis

The Golden Appul

Hye Botoun Shoos

Salade Dayes

Calling Alle Starres

Ziegfeld Folies

Wylde Cat

The Veluet Lady

Biyonde the Frenge

Ich Wolde Rather Be Ryghte

Verray Warm for May

Of Thee Ich Synge

No Strenges

Taak a Chaunce

Putten It in Wrytyng

Anythyng Gooth

Maken Me an Offre

O What a Loveli Werre

Queene of Hertes

Wacche Youre Step

The Moste Happy Felawe

Perchance to Dreme

Finianes Reinbowe

What Maketh Sammy Ronne?

Londoun Laugheth

The Seint of Bleeker Strete

Orange Blossoms

Loste in the Starres

Presente Armes

Londe of Smyles

Yow Ar a Good Man, Charlie Broun

The Plesure of Hys Companye

Sonday in the Park With George

On a Cleer Day Youe Kan See For Evere

Dreame Citee, or the Magyk Knyght

Who Is Affraied of Virginia Woolf?

Wil Succeding Spoilen Rokke Hunter?

Stoppe the World, Ich Desireth for to Geten Of

Peyntyng the Cloudes With Sonne Sheene

A Litel Shake-spere

Comedie of Erroures

Tamyng of the Shrewe

Two Gentilmen of Verona

Luffes Laboures Lost

Richard ii

Twelfthe Nyght

Merry Wyfes of Windsore

Henry iiij

Mesure for Mesure

Wynteres Tale

Kyng John

Marchaunt of Venyce

Muche Ado Aboute No-thyng

Julius Cesar

As Yowe Like It

Troilus and Criseyde

Al Is Wel that Endes Wel

Antony and Cleopatre

The Tempest

Oure remedyes oft in oure-selfen do lye.

Preisinge what is loste maketh the remembraunce dere.

Natures infinit bok of secretnesse.

Ich loveth long lyf bettre than figges.

O Sire! You have lefte unsene a wonderful pece of werk.

Thou techest like a fol.

In tyme we hayte that which we often fere.

Eternite was in oure lippes and eyen.

In the este my plesure lyes.

Thogh itte ben honest, it is never gode to bryng badde newis.

He werith the rose of youthe upon hym.

Make deth proud us for to take.

O, how ful of breirs is this werkyng-dai werlde!

I kan sowke melancholie out of a songe as a wesel sowketh eggez.

It is lyk the howlynge of Irish wolves ageyn the mone.

Boldnesse be my frend.

Herke, herke the lark at hevenes gate singeth.

I ne shal loke upon his lyk ageyn.

Foul deedes wil ryse.

Come, yive us a taste of youre qualite.

This is the weye to kille a wyf wyth kyndenesse.

The pleye is the thynge.

Make that thy questioun, and go rotte.

Manye a goode hangynge preventith a badde mariage.

O spirite of love! howe quyk and fresshe artow.

We have seen bettre dayes.

He that dyeth doth paye al dettes.

Jocounde day stondeth on tiptoon on the mountayne toppes.

O! That I were a glove upon that honde.

She doth teche the torches to brenne brighte.

Conscience is but a worde that cowardes usen.

I wil stande the hasard of the dice.

Trewe hope is swifte and flieth with swalowes wynges.

Thus ich clothe my naked vileynye.

Now is the wynter of oure discontent.

Am I bothe preest and clerk?

Myn herte is turned to stoon; I strike itte and it hurteth myn hand.

Keep up youre brighte swerdes, for the dewe wil ruste hem.

A man loveth the mete in his youthe that he can not endure in hise age.

Lord, what foles thise mortal men be.

I nam nevere merie whan I sweete musyk heere.

To do a gret ryghte, do a litel wrong.

Howe every fool konne pleye upon a worde!

Thow sticketh a daggere in mee.

Wolde that I were in an ale-hous in Londoun!

Brefnesse is the soule of wyt.

Age, I do abhorith thee. Youth, I do adour thee.

O corageous newe world, that hath such peple in it.

The hynde that wolde be espoused to the leoun moost dyen of love.

The webbe of oure lyf is of mengled yarn.

The nature of badde newis enfecteth the teller.

If youe fynde hym sadde, seye I am daunsyng.

Passioun, ich se, is cacching.

Give me to drinken mandragora… that ich myghte slepe.

Whan thou wast heere above grounde, I was a morsel for a monark.

My salad dayes, whan ich was grene in juggement, colde in blood.

Sir, you have wrastled wel, and overthrowen more than youre enemys.

Her-after…I shal desire more love and knowleche of yowe.

The frosti fang…of wyntres wynde…beteth and bloweth upon my body.

The bigge rounde teeres cours oon another down hys innocent nose.

Thou wast as trewe a lovere as ever sighed upon a mydnight pilowe.

From houre to houre we rotte and rotte.

Freseth, freseth, thou bittre skye that doth not byte so nigh.

Tyme travailles in diverse places with diverse persones.

Bidde hem wassh their faces and keepe thair teeth clene.

Despisynge, for you, the citee, thus I turne my bak.

O! A kysse longe as myn exile, swete as my vengeaunce.

Thow hast nevere in thy lyf shewed thy deere modir any curteisye.

O, for a hors wyth wynges!

The aungel of the world maken distinccioun of place bitwene hye and lowe.

Howe wery, stale, flat, unprofitable… al the uses of this worlde.

Thou turneth myn eyen into my verray soul.

Repente what is passed; avoiden what is to comen.

Now craketh a noble herte. Good nyght, sweete prince.

Constant youe ar, but yet a womman.

Letten the ende trye the man.

Forbere to jugge, for we ar synners alle.

How harde it is for a womman to kepe conseil.

Downe on your knees, and thanke hevene…for a goode mannes love.

Rubbyng the poore icche of youre opinioun maken youreself scabbes.

If resouns were as plentiful as blakberyes, I wolde gyve no man a reson upon compulsioun.

Titeles of Bokes

Decline and Falle of the Romain
 Empire

Takynge of Pelham 1, 2, 3

Deth in Venice

Travailes With Myn Aunte

Storie of an Affricanes Farme

Journee to the Centre of the Erthe

Vicaire of Wakefield

Jerusalem Delyvered

The Jew of Malta

Passage to Inde

Est of Eden

In the Wildernesse

Journee to the Ende of Nyght

To Kille a Mokkinge Brid

The Ugli Dokeling

Oxe-bowe Incident

Litil Foxes

Juno and the Pecok

The Goldene Asse

Scarlet Clawe

Pale Hors, Pale Ridere

Shoos of the Fissherman

The Serpent and the Rainbow

Petre Rabette

Beaute and the Beest

Feithfull Shepherdesse

The Frogges

Blak Lomb and Grey Faucon

Snake Pit

The See Hauk

Lord of the Flyes

Crokke of Golde

Dreeme of the Rede Chambre

Bloo Berde

Dragoun Seed

The Silver Chalice

Blak Beaute

For Evere Amber

Jason and the Goldene Flees

Pacche of Blew

Studie in Scarlet

Reflexiouns in the Golden Eye

Rideres of the Purpul Sauge

The Alkamist

Jude the Obscur

Retourne of the Natif

The Goode Souldioure: Schweik

Syns You Wente Away

For Whom the Belle Tolleth

Ulixes

Slepynge Beautee

The Spainish Gardener

Straungiers Whan We Met

Goostes

The Weiker Sex

For Youre Eyen Oonly

Charlottes Webbe

Eve of Seinte Agnes

Unfeithfulli Youres

Gentilman Dauncyng Maistre

The Fairye Queene

Spoylers

Kinges in Exile

Felawshippe of the Ringe

The Honeste Hore

Laste of the Barouns

Ercules and Hys Twelve Labours

Lady of the Lake

Knyght of the Brennynge Pestel

The Thinne Man

Legend of the Moures Legacie

Prometheus, Unbounde

Lay of the Last Mynstralle

Goode Compaignyon

The Lytel Ministre

Pilgrimes Progresse

Deth Cometh for the Archebisshope

The Titan

As Ich Lay Diynge

Lady Windemeres Fanne

Kynge Salamones Mines

The Lady Nis Not for Brennynge

Anne of Grene Gables

Not Withouten Myn Doghtre

Looke Homewarde Aungel

The Wanderynge Jewe

Moornynge Bi-cometh Electra

Lord of the Rynges

The Ydiot

Shippe of Fooles

Shepherde of the Hilles

Odde Man Oute

Prynce of Tydes

The Disciple

Olyver Twiste

Fadres Delicaat Condicioun

Nynetene Four-and-Eighti

The Moone and Sixe Pens

And Thanne Ther Were None

Oon-Thousand-and-Oon Nightes

Two Yeeres Biforn the Mast

Harpe of a Thousande Strynges

Roum at the Toppe

Wyndmylles of the Goddes

Schole for Scandle

Cloistre and Harthe

Mordre in the Cathedral

Sanctuarie

Of Humain Bondage

Loyaltees

Farewel to Armes

Hous of Myrth

The Swerd in the Stoon

Roum With a Vewe

Garde of Honour

Harde Tymes

Werre of the Worldes

The Frenssh Conneccioun

Hyt Is Werse Than Hit Was

Touche of Yvel

The Waste Londe

Cryme and Punnysshment

Leves of Gras

Wynde in the Wiloghes

Grapes of Wrathe

Randoun Harvest

On the Origine of the Species

Devine Comedie

The Magik Mountaigne

Paradys Lost

Derk Laughter

Olde Mortalite

The Robe

Smal Sacrifices

Ronne Silent, Renne Depe

Telle Me a Ridel

Frendly Persuasion

The Hool Towne Is Talkynge

A Walke on the Wilde Syde

Remembraunce of Thinges Passed

The Lighte That Fayled

Night-mare Abbeye

Goddes Litel Acre

Humaine Comedie

Cakes and Ale

Age of Innocence

The Possessid

Werkes and Dayes

Gon Wyth the Wynde

The Power and the Glorye

Rideles of the Sandes

Tendre Is the Nyght

Under Capricorne

Tropik of Cancer

The Sound and the Furie

Bareyne Grounde

Honde Fulle of Dust

The Hete of the Daye

Highe Wynde Risyng

Lost Orizonte

The Idus of March

Virgin Soil

Snow-bounde

The Linke

Vanitee Faire

Pryde and Prejudice

Twiste of Fate

The Verdict

Lost Illusiouns

The Good Erthe

Shynyng Thurgh

Vanysshed

Thurw a Glas Derkly

The Hidyng Place

Lokynge Bakward

Hooly Terrours

The Litell Cley Carte

Derknesse at Non-tide

Loste Wekes Ende

Whan Tomorowe Cometh

The Glas Keye

Pointe Countrepoint

Shee Stoupeth for to Conqueren

Snow-whit and the Sevene Dwerfes

Brefe Narratifz

The Secret Lyfe of Walter Mitty
Howe Beauteful With Shoon
That Evenyng Sonne
The Boy Who Cryde Wolf
Fall of the Hous of Usher
Racheles Teeres
The Unicorne in the Gardin
Seventene
The Catte-Brid Sete
Raunsoun of Red Chief
A Rose for Emelye
The Swimmer
Wilde Gees
A Litel Girl fro Towne
The Raven
Knele to the Risyng Sonne
After Noon of a Fawne
The Killers
Silent Snowe, Secret Snow
Perles of Loreto
The Open Bote
Barre Sinistre
Som Lyk It Colde
The Real Thynge
Invisible Colleccioun
Yonge Good-man Broun
The Boie Who Dreue Cattes
The Purloined Lettre
Turne of the Skrewe
The Moost Daungerous Game

Ther Will Come Softe Raynes
Man Withoute a Contree
The Open Wyndowe
A Worne Path
The Collectour
A Gode Man Is Harde to Fynde
Rokkinge-Hors Winnere
The Animal Kingdom
A Praiere Somer Mornyng
Everi-dai Use
The Bloo Bedes
Blessid Are the Meke
Champioun
The White-boys
Visitinge Day
Rennyng Awey
The Consul
A Dore in the Wall
The Perfit Tribute
Oon Autumpne Night
Sabath Breker
The Maister of the Inne
Herte of Darkness
In Another Contree
The Ledere of the Peple
A Whistleres Roume
Frende of the Famillie
The Conseil Assigned
Adam & Eve & Pinchen Me
The Blak Cat
Envoye
The Heir at Lawe

Lucius Merlin and Lilye, Hys Wyf

Lawe Beters

The Farewel Mordre

Fair and Stormy

Lobstere Johannes Annie

The Apostate

Destynee and a Dogge

The Telle-Tale Herte

Fyne Fetheres

Myn Honoured Maister

Clorinda Walketh in Heven

The Drawen Arowe

His Widowes

Oure Ladies Jogelour

The Laste Lessoun

Rappacinis Doghtre

The Legende of Slepy Holowe

The Wisshe Book

The Magik Talkinge Boxe

Al Thynges Considered

The Shadough Knoweth

Straunge Doctour Werde

Lightes Oute

Tales of To-morwe

Doctour Christien

Our Maistresse Brookes

Bradbury Thrittene

Stroke of Fate

Thornton Centre Stage

Misterie in the Eir

The Firste Arte

Moone Over Affrike

Erthe Serche

Seint Paul Sondai

The Cynamome Bere

Doctour Kildare

Mordre at Mydnight

Mr. Kene, Tracer of Loste Persons

Rokki Fortune

The Chase

Canticle for Liebowitz

Suspense

Orson Welles Theatre

The Whistlere

Newe Aventures of Nero Wolfe

Chandu, the Magicien

Oon Mannes Familie

The Lyves of Harry Lime

Escape

Ich Love a Misterie

Night-bete

Journee into Space

The Seled Booke

Kincaid, the Straunge Seker

Biside-the-Fire Talkes

The Shadowe of Fu Manchu

Feere on Foure

X Mynus Oon

Graunt Centre Stacioun

The Seinte

Twenti Questiouns

Grene Valeye Lyne

Night Falle

Gunne-smoke

Werre of the Worldes

Myn Worde!

Music Til Mid-night

The Shape of Thynges to Comen

Night-wacche

Frountier Towne

Praiere Hom Compainyon

Luke Slaughter of Tomb Stone

The Fifthe Hors-man

Mornynge Edicioun

Halle of Fantasye

Fresh Aire

Have Gunne, Wol Travailen

Alien Worldes

Box Thrittene

The Sixe Shuter

Fortresse Laramie

Mark Traile

Mercurie Sommer Theatre

Orisontes Weste

My Music

The Werde Cercle

By-yonde Tomorwe

The Fatte Man

Doctour I Q

I Love Aventure

Frountier Fighters

Cloke and Daggere

The Blak Masse

Cryme and Peter Chambres

Dimensioun X

Take It or Leve Itte

Damon Runyon Theatre

Ne Slepe No More

Doctour Savage

Lette Us Pretende

Dark Fantasye

The Slide

Spine Chilling Tales

Cryme Doth Not Paye

Capitain Mydnyght

Space Force

Frountier Gentilman

Breke-faste Guilde

Red Ridere

Alien in the Minde

Starres in the Air

Names fro the Magyk Pictour Box

Fader Knoweth Best

Victorie Gardenne

Leve Hyt to Bever

60 Mynutes

Tales fro the Cripte

I Luffe Lucy

Byg Brother

Derk Shadowes

Saterday Nyghte Alive

Outer Lymytes

Al in the Familie

Bewycched

The Gost and Maistresse Muir

The Love Bote

Kepynge Up Apparences

Gyding Light

Onys a Theef

Austyn City Lymytes

Papir Moone

Peticote Juncture

Skye Kynge

Oon Step Biyonde

Faste Foreward

The Avengeres

Man fro U.N.C.L.E.

Suster, Sustre

Naked Citee

The Practise

Surviver

Viktori at See

I Dreame of Jeannie

Wynges

As the World Turneth

Seventhe Hevene

Falcon Crest

Chasynge the Sonne

Cheres

Grene Hornet

Touched by An Aungel

Jupardye

30 Som Thyng

The Brady Bunche

Dayes of Oure Lyves

Holly-woode Squares

Serche for To Morowe

Xena: Werior Princesse

In the Hete of the Night

Sisamie Strete

Ful Hous

Loste in Space

Mickey Mous Gylde

The Fugitif

Ronne for Youre Lyf

Walle Strete Weke

Up the Staires, A-doun the Stayres

The Peples Chois

Passiouns

Mordre, She Wrot

Buffy, the Blod-Sokor Slaer

Doctour Quinn, Medicyne Womman

This Was the Weke That Was

Maried With Childryn

Londe of the Loste

Eighte Is Ynough

Youe Ne Wil Nevere Getten Riche

Houre of Power

The Girl Wyth Som-thyng More

This Is Youre Lyf

Make Roume for Fadir

Oon Lyf to Lyve

Wheel of Fortune

Yonge and Restles

Private Secretaire

Different Strokes

Fyr at See

Ripleyes Bileve It or Not

Spither-Man

Grace Undir Fyr

Testimonie

Duffyes Taverne

Sense and Sensibilitee

Growyng Peynes

Home Emprowementes

So Litel Tyme

Outrideres

The Wondre Yeres

Superior-Man

Golden Girls

Eighte-and-Fourty Houres

Preise the Lord

Luve That Bob!

Twilight Regioun

No-Honestly

Star Expedicioun

Elleventhe Hour

Oon-and-Twenti

Behynde Closed Dores

Invisible Man

State of Grace

My Favoured Husbonde

If Walles Koude Talke

Familie Ties

My Moder, the Carre

Growynge Peynes

Secretis of the Ded

Charmid

Roum for Change

Grene Acres

Thre Is Companye

Sodeinly Susan

Happy Daies

Silver Spoones

Crossyng Over

Kynge of the Hil

Parfit Straungiers

Whos Lyne Is It Ani-wise?

Itte Is a Myracle

Egiptes Citee of the Ded

Lawe and Ordre

I Ledde Thre Lyves

Divorce Court

Spynne City

Providence

Goode Tymes

II. Succincte Thoughtes

Attencioun!

Every Thyng Undir the Sonne
Maken Youre Dreemes Com Trewe
No Body Doth Itte Better
Same Dai Servyse
Qualite Repaires
Free Deliveri
Two for the Pris of Oon
For Men Oonly
Irish Nede Nat Applye
Free Estimat
Discreet Enquery
More for Youre Moneye
Servise With Integrite
See Houres of Operacioun
Every Day Low Prises
Coost to Coost Moeveres
Ayr Condiciouned
Introductorie Offre
Moevyng Maad Esier
We Do Wyndowes
Newe and Used
We Bye and Selle
Curteys Servise
For the Entier Familie
No Servyse Charge
Trye Bifore You Bye
Bisynesse as Usual

Payd in Fulle
Paiement on Demande
No Questiouns Axed
We Bete Any Price
Whyte Glove Servise
Loweste Prises in Towne
No Broker Fees
Solide woode floores
No Moneye Doun
Four and Twenti Houres Every Dai
Why Wayte?
We Ar Nombre Oon
Your Wysh Is Oure Comaunde
We Trien Harder
What a Bargayn!
Ich wolde walken a mile for a camaille.
We bringen goode thinges to lyfe.
Gode to the laste drope
Rede this first!
Awey go troubles downe the dreinhol
Delta is redy whan yowe are.
Glad to ben of servise
Loos lippes synketh shippes.
Brek-faste of champiouns
Gat milk?
Incredible etable egges
Wher is the beef?
I can not beleeve I have eten the hoole thyng!

In God we trusten.

A citee in a gardyn

Do not treden on mee.

The citee of brotherli love

A centurie of progresse

Accion now!

Go west, yonge man!

Joyne the navye and se the worlde.

We neede a fewe gode men.

Reyn or shyne, we leve at nyne.

All thinges in moderacioun

A dram is bettre than a damme.

Life ginneth at fourty.

Urgent Care Centre

Familie Practike

Fostre parentes

Womman to woman

Lavatorie Up the Staires

No Loitering

No Riffe Raffe Allowed

No Soliciting

No Trespassynge (!)

Stoppe

Slowe

Yelde

No Lefte Turne

No Righte Turne On Reede

Ne Stopping Nevere

Caucion—Animal Crossynge

Brigge Openeth at None-tyme

Men Werkynge in Trees

Stoppe. Looke. Listeth.

Flooded Duringe Reyn

Wacche for Fallynge Rokkes

Ffines Double Neer Construccioun

Werk in Progresse

Kepen Of the Gras

Gon Fysshynge

Doon Not Disturben

Handle with care

Special deliveri

Retourne to sender

Chek-mate!

Famouse Wordes

I have a dreem.

My God, wherfor and why has thou forsakyn me?

It is bettir to lyght o candel than to cursen the derknesse.

Yoe can not kille tyme withouten doing injurie to eternite.

I thynke, therfoore I am.

That gouvernement is beste that governest leeste.

It is a fer, fer bettir thynge I do than I have ever doon bifore.

Quod the Raven, "Nevermo."

I cam. I saugh. I conquered.

Walk softely, but carie a bigge stikke.

We have no thing to feere, but fere itself.

Oportunitee is the great baude.

A hors! A hors! My kyngdom for a hors!

Lat hem ete cake.

Encense is an abhomynacion.

Foul whisprynges are abrode.

Abandoun al hope, ye who entre heer.

Absolut power corrupteth absolutly.

Brothel houses are bilt wyth brikkes of religioun.

Bynethe the spredinge chestain tree, the village blaksmith stondeth.

Frendes, Romayns, contreymen, lene me youre eres.

Man is the oonly animal that blussheth, or nedeth to.

The abbreviacioun of tyme tyngeth the evenyng of lyfe.

Phisicien, heele thi-self.

I am the handmaide of the Lord.

Tigre, tigre brennynge brighte.

Yive me chastitee and continence— but not yet.

Love conquereth alle.

A thing of beautee is a joie for ever.

Lord, open my lippes and my mouth shal declare Thy preise.

In the dewe of litel thynges the herte findeth morninge and is refreshed.

Ne aske nat what youre contree can do for you, but rather what youe kan do for your contree.

The moevyng fynger writeth and havyng writ, moeveth on, nor al your pietie nor wit can lure it bak to cancell half a lyne nor alle youre teeris wasshe oute a word of itte.

Olde Sawes

A brid in the hand is worth two in the bussh.

Fighte fyer with fyer.

Oonly the good dye yong.

Hee who laugheth last, laugheth beste.

Like fader, like sone.

Love is blynd.

Oute of sighte, out of minde.

Love thy neighebore.

Mordre wille oute.

Divide for to conqueren.

No newis is gode newis.

Helle ne hath no furie lyk a womman scorned.

Al is faire in love and werre.

Beautee is oonly skyn depe.

Acciones speken louder than wurdes.

An ounce of prevencioun is worth a pound of cure.

Knoweliche is power.

Ne axe me no questiounes, I wolne telle yoe no lyes.

Moneye is the roote of alle evel.

Too many cookes spoilen the broth.

Ignoraunce is blisse.

A newe broome swepeth clene.

Hony cacceth more flyes than vinegre.

A stiche in tyme savith nyne.

Necessite is the mooder of invencioun.

Whenne all elles faileth, reed the instrucciounes.

The moore the myrier.

No persone is parfit.

Never nis a place bettre than hom.

Oon gode turne deserveth another.

Out of the friyng panne into the fire.

Se no yvel. Heere no evel. Speke no yvele.

Ne putten nevere the carte biforn the hors.

Oon mannes mete is another mannes poyson.

The bigger they ar, the harder they falle.

Ne byteth never the hand that fedeth you.

Ther ben no fool lyk an oolde fool.

Beggers can not chesers be.

Ne counten nevere youre chiknes afore they hacche.

The spiryt is willyng but the flessh is weik.

Erly to bedde, erliche for to ryse, giveth helthe, welthe, and wysdom.

Who steleth myn purs, steleth trash.

The older the fidel, the swetere the tune.

What good is for the goos, goode for the gander is.

Wher ther is lyf, ther is hope.

Youe can not everything have.

Feynt herte ne wonne faire lady never.

Ther be manye a slip bitwix the tonge and the lippe.

He who payeth the piper calleth the tune.

You can not wynne hem alle.

Fooles rush in wher aungeles feere to tred.

Trouthe is straunger than ficcioun.

An appul a day kepeth the doctour awey.

Youe can not taketh itte with youe.

Absence maketh the herte growe fonnish.

Abstinence maketh the flessh growe fonnish.

A fol wereth hys herte on his sleve.

Lightnynge never strikes the same place twies.

Speche is silver, but silence is goldene.

Even the walles have eres.

The erly brid geteth the worm.

Ne letten the cat oute of the bagge.

The gras is alweyes more grene in the nexte pasture.

An eie for an eie; a toth for a toth.

Moder knoweth beste.

Hyt is an ill wynd that bloweth no goode.

Onys biten, tweis shei.

Take the bittre wyth the swete.

Heere to-day, y-gon to-morwe.

Seise the daye.

The beste thynges in life are fre.

Juggen not a book by the cover.

Ne hiden not your lyght undir a busshel.

Foryive and forget.

Ignoraunce of the lawe nis no excuse.

Hope for the beste but preparen for the worste.

Give hym an inche and he wol taken a mile.

Maken hay while the sonne shyneth.

Beautee is in the eigh of the byholdere.

Ne mincen not wrdes.

Familiarite bredith contempt.

Familiarite bredeth atempte.

Putten youre money wher youre mouthe is.

Aprill shoures bringen May floures.

Wher ther is a wyl ther is a wey.

Litel picheres have byg eres.

A fol and his moneye ar soone parted.

Speke whan yowe are spoken to; com whan yoe are called.

You can not maken a silk purs from a souwes ere.

If thou can not stonde the hete, get out of the kichen.

The derkest houre cometh just before the dawnynge.

Gode thynges com in smal pakets.

The penne is myghtyere than the swerde.

Kepe a stif over-lippe.

Put youre best foote foreward.

A wys man forsees the pit-falles.

Lat slepynge dogges liggen.

Bettre saffe than sory.

Those who lyven by the swerde, dyen by the swerde.

Love mee, love myn dogge.

Gif it youre beste shot.

Bettre call the plummer.

Alwey were sensible shoos.

Itte is bettre to ben an alive mule, thanne a ded leoun.

Idel hondes ar the develes bisynesse.

Badde newis travailleth faste.

A mynde is a terrible thynge to waste.

Evyll wol triumphe whan goode men do nothynge.

Youe can not nevere techen an oold dogge newe trikkes.

Ne trusten nevere thise newefangel machinamentes for computacioun.

Itte nevere nis over until the fatte ladie singeth.

Famous Laste Wordis
Foolisshe or Serious

I knowe what I am doynge!

Accidentes wil happen.

I am to yonge for to dye.

Do not touch that!

Thre is a familie.

This tyme is for alwey.

Rennen for youre lyf!

Ther is always tomorwe.

Youre thre minutes ar uppe.

Se yow in the mornynge.

Over my ded body!

Everich clowde has a silver lyning.

Truste mee.

Who gooth ther?

You wil liken my moder.

Do you feele the erthesschakynge?

Thridde tyme is a charme.

Helpen is on the weye.

Hyt coude be worse.

Fido biteth not.

I am certeyn the foode is stille freshe.

Cros myn herte, and hope to dyen.

I do not neede the mappe.

No experience required.

The peynt oughte to be drye by now.

We, who are about to dyen, saluten
 youe.

What a monstruosite!

My entencciounes ar honourable.

This wil nat hurten.

If it be not the trouthe, may
 lightnynge me striken.

Ther ar no todestooles in this part of
 the forest.

I see no beare in this cave.

Ik wondren wher all the water is
 cominge fro.

That was mete you were savynge for
 the dogge?

Even in the derke ich knowe where
 the trappe is.

Phisicienes Wordez for Anathomye and Siknesse

pacient
quick and ded
skulle
craneum
mandible
jawys
nape of nekke
schulder blades
ribbes
thorax
umbilic / nauel
armes
humerus
elbowe
handes
knokel
nayles
bak-bone
hippes
tayle bone
legges
thighe
knee
calf
shin
ancle
fete
toos

extremytees
scalp
forhed
face
frekled / wryncles
temples
browes
eyen
cornea
rethina
pupilles
teres
eye lidd
eres
nose / nostrille
sinus
chekes
lippes
mowthe
palate
tonge
skyn
flesche
jointes
senewes
bones
tibia
cartilages
ligamentis
muscles
pericranium
brayne

medulla
uvula
epiglotus
throte
trachea
lunges
pipes of the longes
ysophagus
duodenum
stomak
glandes
splene
lyuer
bladder
membrane
pericardium
herte
ventricle
blood vessellis
veynes and arteryes
bowels / guttes
entraylles
perytoneum
groin
testicles
genitalz
prepuce
rectum
buttokes / foundement
gender
adolescence / pubescence
feminine

bareynesse

impediment

masculine

hermofrodito

impotence

menstrues

maydenhed

ereccioun

defloracioun

coite

semen / sperm

fertile / fecunde

concepcioun / procreate

embrio

pregnaunt

mydwyf

child-berthe

newe borne

ded-born

brest / tete

eye-sight

fnese (snese)

voyce

chewynge /
 masticacioun

swolowynge

appetit / digestioun

brethynge / respiracioun

coughe

pulse

muscilage

swetynge

shiten

voydinge

pissynge / vryne

condicioun

vertigo

melancholie

madness

apoplexie

migraine

catalempsi

lyse and nits

ballednesse

pymples

catheractes

blyndenesse

nose thirle bledynge

hyssynge in eres

ere wax

defnesse

rotynge of teeth

tothe ake

mute / dombe

lisping

pleuresye

indigestioun

eructacioun

herte-brenninge

nausea / quesie

vomyte

aneuresma

palpitacioun

galle

stone in the bledder

hernia

ruptur

diaria

flux

constipacioun

fartyng

sciatica

priapasme

emoroydes

fistula

varicose

trumbose

slavering

feyntyng / swounynge

corpulent

clift

colerik

sallow complexioun

constriccioun

depilacioun

viscosite

streyne

spasm

crampe

paroxism

akynge

twycche

litargye

feverish

infermetee

feblenesse

palsye

debilite

purulente

congeled

contraccion

jaundice

carbuncle

erupcioun / pus

gowte

wartes

vlceres

ydropesye

schingles

reumatyk

crokednesse

deformitee

infeccioun

festre

curvature

wormes

stynges / venym

tetane

quinesye

desiccacioun

irritacioun

chafynge

ycchinge

swellynge

blistrynge

corrupcioun

fetid

wen / nodulum

tumour / polip

contagiouse / epidemic

dissenterie

pokkes

ring-worm

destemperen

venerealle

herpes

impetigo

leprouse

injurie / accidentes

lacerate

woundes

depe / superficial

bitynge

smytinge

scaldynge

brusynge / contusioun

brennynge

mangled

scabbe / scar

paralityk

lame / crippel

brooken bones

fractures

dislocaciounes

wrenche

bones out of joynte

traccioun

articulacioun

reduccioun

mobilitee

examynacioun

curynge / helynge

benign

recoverie

remissioun

remedyes

enoyntinges / oyle

rubbynge

diete / nutricioun

fastynge / purgynge

dentifricie

diuretik

suppositories

laxatyf

injeccioun

flebotomie

tincture

elixir / pocion

stiptik

fumygacioun

vapour

unctioun

oynementis / bawme

salve / locion

plastres

farmacie / medicyne

evaporacioun

distillynge

alkali

raynewater

campher

camomyle

petroleum

sulphur

asa-fedita

terbentyne

surgien

suppine

operacioun

truncacioun

ligature

stupefaccioun

drugges / narcotikes

inscicioun

rasoure / kuttynge

perforacioun

launcet

probe

nedel and thred

sewe / suture

scisoures

shavynge

gelding

circumcisioune

instrument

ciringe

cautery / corrosyues

sedacioun / opium

byndinges

abstinence

incurable

stumpe

bedriden

urinals

putrefaccioun

suffocacioun

drownynge

strangelynge

decollacioun

suicide

expire

embawme

III. Variousnesse of Musyk

Songes to God

Blesse the Lorde, O Myn Soule
In Cristal Toures
Alle Glorie, Laude and Honour
O Sacred Hed Sourrounded
Soule of Myn Savyour
Crist, Whos Glorye Filleth the Skye
Weren You Ther?
At the Lambes Hye Feste
Come, and Lat Us Swetely Joyne
Bewteful Saveour
Sheepe May Safliche Grasen
Fader, Yive Thy Benediccioun
Gadere Us In
Opyn Myn Eyen, Lord
Ther Is a Longynge
Gift of Fyneste Whete
Lat Us Brek Bred To-gidre
Gyve Mee That Old Tyme Religioun
Wher Charitee and Love Prevaille
A Myghty Fortresse Is Oure God
O God, Our Helpe in Ages Passed
Seken Ye Firste
Lat Us Liften Up Oure Hertes
On Egles Wynges
Jhesus Calleth Over the Tumolte
Ich Knowe You Are Nere
A-masynge Grace

They Wil Knowen We Are Cristenes
Citee of God
Com Gracious Spirit, Hevenely
 Douve
Feith of Our Fadres
Ther Is a Bawme in Gilead
Shepherde Mee, O God
Jesu, Lorde of Lyfe and Glori
To the Hilles, I Wil Lifte Myn Eyen
Create In Me a Clene Herte, O God
Whatsoever Yowe Do
O Lord, Withinne Thy Tabernacle
Jerusalem, My Happy Home
Creatour of the Starres of Nyght
Jhesu, Joye of Mannes Desiringe
Fadir Eternel, Reuler of Creacioun
Abyde With Me
Morenynge Has Broken
O Lord, Looke Doun fro Hevene
Lat Ther Be Pese on Erthe
Sente Forth Bi Goddes Blessynge
The Lorde Is My Oonly Supporte
Erthen Vessels
Myn Eyes Have Sene the Glorie
Jhesu Crist Is Risen To-day
Pees Is Flowynge Lyk a Ryver
Ich Knowe That My Redemer Lyveth
The Chirches Oon Foundacioun
We Gadre Togedre
The Spacious Firmament on Hye

47

Jacobes Laddre

Joyeful, Joyfull, We Adoure Thee

Remembre Not, Lord, Oure Offenses

On This Day, the Firste of Dayes

Oure God Regnes

Blest Ar the Pure in Herte

Just a Closer Walk With Thee

I Am the Resurreccion

Spirit of the Lyvynge God

To Myn Humble Supplicacioun

Lifte Hye the Cros

Jhesu, Thow Devyne Compainoun

Alleluya! Sing to Jhesu

Crowne Hym Wyth Many Crounes

O Come and Mourne With Me a While

God, the Omnipotent Kyng

Lord, Teche Us How to Preye Aright

Al Hayle the Power of Jhesus Name

To Jesus Crist, Oure Sovereyn King

Rokke of Ages

Ner and Ner My God to Thee

Blessyd Be the Teie that Byndeth

Preise Him, Preyse Hym

Com, Thangful Peple, Come

The Word Is a Lanterne

Be Stille My Soule

How Ferme a Foundacioun

The Voys of God Is Calling

Gret is Thy Faithfulnesse

Be Thow My Visioun, O Lord

Love Liftid Mee

Man of Sorwes, What a Name

Never Allone

Taak My Life, Lat Itte Be

Jhesu, Name Above Al Othir Names

At Even, Er the Sonne Was Sette

My Feyth, It Is an Oken Staffe

Gentil Mary, Meke and Mylde

Jugge Eternel, Troned in Splendure

Now, Fadir, Mindful of Thy Luve

Joy Dawed on Ester Day

Ne Passe Me Not, O Gentil Savyour

He Ledeth Mee, O Blessid Thoughte

Jhesu, Tresour Withouten Pris

Hertes to Heven and Voices Reyse

God Be With Yoe Til We Mete Agayn

Alle Thynges Brighte and Beuteful

Com, Thou Almyty King

Holy Grounde

The Oolde Rugged Crosse

Troned Upon the Awfull Tree

My Soule Doth Magnifie the Lord

Gracyous Spirit, Dwelle Wyth Me

The Lorde Is Present in Hys Sanctuarie

Bow Doune Thyn Ere

Precyous Lord, Taak Myn Hand

Onward Cristen Souldiours

Entre, Rejoyse, and Come In

Blessid Assurance

O Considere My Adversitee

Al Peeple that on Erthe Do Dwelle

O Wurd of God Incarnate

Broken and Spild Oute

Alle Myn Hope on God Is Founded

O Lord, I Nam Not Worthi

Ayeyn, as Evening Shadowes Falle

Withoute Seing You

Ryse Ayein

Al Creaturis of God Oure Kyng

Attende Myn Humble Prayere

Acordynge to Thy Gracius Wurde

Ther Is Withinne Myn Herte a Melodye

Ther Is a Wydnesse in Goddes Mercy

O Man, Forswere Thy Foolisshe Weyes

O Parfit Love, Al Humain Thoughte Transcending

Blesse Thou the Gifftes Oure Handes Have Broght

God of Oure Fadres, Whos Almighty Hande

How Bryghtly Shyneth the Morninge Starre

I Soughte the Lorde, and Aftirwarde I Knewe

Fro Alle that Dwelleth Bynethe the Skyes

Preyse God from Whom Al Blessynges Flowen

I Wol Singe of the Mercyes of the Lord

Alleluya! Alleluia! Lat the Hooly Antheme Ryse

Thou Knowest, Lord, the Secretis of Oure Hertes

For Al the Seintes Who fro Thare Labours Reste

Breke Forth, O Beuteous Hevenlich Lighte

Bilt on the Rokke, the Chirche Doth Stonde

Fadir, to Thee We Loken in Oure Sorowes

Lede Kyndely Light A-midde the Surrounding Glowmbe

He Has Got the Hoole World in Hys Honde

Musyke Oonly for Plesure

Septembre Song

I Dide It My Wey

Come Reyne, or Com Shine

Alweys

You Do Som-thyng to Me

Lucy in the Skye With Dyamauntz

Gesse Who I Saw To-day, My Dere

Gete Out of Towne

Mene Mr. Mustard

My Kynde of Town

Teche Me To-nyght

Until the Real Thinge Cometh Along

Do Not Sitte Undir the Appel Tree

Summe Oone to Lyght Up My Lyf

Peny Lane

Kepyng Out of Meschief Nowe

Celestial Aida

Quiete Nyghtes of Quiete Sterres

The Lampe Is Lowe

Starres in Myn Eyen

Aungel Eyes

Smoke Getith in Youre Eyen

Derk Eyen

Dauncynge in the Derke

Whan Day Is Y-do

By the Lyghte of the Silveri Moone

Here Is That Raini Day

Luver Come Bakke to Me

I Let a Song Go Oute of Myn Herte

Do Not Blame Me

Watres of March

Lyghte My Fyre

Blewe Flaume

I Am Begynnynge to See the Lighte

Jeannie Wyth the Lite Broun Heer

For Luffe of Ivy

Trouble in Mynde

Brigge Over Troublid Watris

Wrappe Youre Troubels in Dremes

Litel Broun Jugge

My Devocioun

Just the Weye You Looke To-nyght

Pakke Up Youre Trubbles

Poket Fulle of Dremes

Biyonde the Blewe Orizonte

You Ought to Be in Pictoures

Penies from Heven

Strawbery Feeldes For Ever

Purpel Peeple Etere

The Shadwe of Youre Smyle

Shyne on Harviste Mone

In the Stille of the Night

Stormy Wether

Bicause

Tellen Mee Why

The Verray Thoghte of You

Wher Have Al the Floures Gon

You Weere Mente for Mee

Nevere on Sonday

We Wil Meete Agayn

Lovere, Whan You Are Neer Me

What Is This Thyng Called Love?

I Wol Remembre Aperil

How Long Has This Y-ben Goinge
On?

Atte Longe Last Love

The Laste Rose of Somer

Al I Have for to Do Is Dreame

What Kynde of Foole Am I?

Hard Dayes Nighte

Poysoun Ivy

xvj Candeles

A Straunger in Paradys

Tyl the Clowdes Rolle By

Whistle Whil You Werk

Wisshe You Were Heere

Somwher Over the Reinbowe

That Oold Blak Magique

The Music Goth Rounde and Round

Putte on Youre Oolde Grey Bonet

Love Is Swepynge the Contree

Cheke to Cheke

I Have Got the Werlde on a Streng

Thre Coynes in the Fountain

It Was a Verray Goode Yeer

Shoute!

Luve Walked Ryghte In

A Rokkinge Goode Way

To Knowen Hym Is to Luffe Hym

Wake Up, Litel Susie

Sholde We Telle Hym?

Crye Me a Ryvere

With a Litil Helpen fro My Frendes

I Cride for You

Yesterdayes

Any Weye Youe Like It

The Fool on the Hille

Nature Boy

Twiste and Shoute

Slepyng Geaunt

Slepinge Bee

Do Nothyng Til You Heere fro Mee

Takyng a Chaunce on Love

Ther Is No Gretter Love

Luve Me or Leve Mee

The Verray Thoghte of You

Help!

The Whyte Cliffes of Dovere

Dere Prudence

Silver Thredes Among the Gold

Lyf Is Just a Bolle of Cherys

South of the Bordure

North-west Passage

Sonne-rise, Sonne-setting

Thre Litel Fysches

Can Not Bye Me Luffe

Doth Youre Herte Bete for Me?

A Sonday Kynde of Luve

And Ich Love Hir

Dereli Biloved

Oon Fyne Dai

My Shynynge Houre

Body and Soule

Luffe Me Tendre

Whan Youe Are Smylinge

It Al Dependith on You

I Gette a Kyke Oute of You

I Desire to Holden Youre Hand

To Clos for Confort

Supersticioun

Onys in Love With Amy

What Evere Lola Desireth

Septembre in the Reyne

Jale-hous Rokke

You Bilong to My Herte

Som-bodi Luves Me

Clymben Everich Mountain

Whisperinge Hope

Sommer Tyme

Bak in the USSR

Mokkinge Brid Hille

Litel Sire Ekko

Beinge for the Benefit of Mr. Kyte

Michael Rouwed the Boet A Shore

Lat Us Face the Musik, and Daunse

Whan the Seintes Go Marchynge In

Est of the Sonne, West of the Mone

Who Is That Knokkynge at My Dore?

Waite Til the Sonne Shyneth, Nellie

I Wil Nat Last a Daye Withouten You

You Are the Sonne-shine of My Lyfe

The Moost Beuteful Gerl in the Worlde

I Thinke I Am Goinge Out of My Minde

Dide You Ever See a Dreeme Walkyng?

Yowe Have Loste That Loving Feelynge

The Nyght Is Yonge and You Are So Beauteful

I Am Getynge Maried in the Moroweninge

Softely, as in a Morenynges Sunne Ryse

I Have Spurren That Gyngle, Jangle, Gyngle

Gesse I Wil Hang My Teres Oute to Drye

A Nighytyngale Soong in Berkeley Square

I Wol Be With You in Appel Blosme Tyme

The Sterre Spangled Banner

Snacches of Songges fro Engelond (and Scot-lond)

Ther was a joly beggere, and a-beggyng hee was born.

I telle youe be war of the ripling, yonge man, thogh the sadel ben softe, you nede not ryde ofte.

Ich sawe an urchoun shape and sowe, and another bake and brewe.

As ye wyssh my wyll is bent, in everything to be contente.

Myn yeeres be yonge, even as youe see. Al thynges therto doth agree.

Blowe, thy horn, hunter, and blow thy horn hye. There is a doe in yonder woodis, in feith shee wol nat dye.

I am a joly forster and have ben many a dai.

This othere daye, I herde a mayde, righte pitously compleyne.

Ther was a frere of order gray...which loved a nonne ful many a dai.

It was a mayde of brennynge ars. She rood to mille upon a hors.

She cherisshed hym, both cheke and chynn. He wiste never wher he was.

Goode Kytt hath lost hir keye. She is so sory for the cause.

As I wente on Yewle Daye in oure processioun, knew I Joly Jankin by hys merie tone.

Lord, so sweete Sir John doth kisse, every tyme whan we wolde pleye.

This othere day I mette a clerk, and he was willynge in his werke.

Ledde I the daunse a Mid-sommer Dai. I madeth smal trippes, soothe for to seye.

Sins the tyme I knew you firste, youe wer my joye and truste.

My sovereyne lord, for my poure sake, sixe coursis at the ryng did make.

If thou hath but litel moneye, spende itte not on folye.

Of servynge men I wil begynne, for they go pratily trym.

I preye youe com kisse me, my litil prettie Mopsie.

Myne owne dere ladie faire and fre, I pray youe, in herte pitee me.

Is ther any goode man heer, that wil maken me any cheere?

"*Pax vobix*," quod the fox, "for I am com to towne."

Walkynge in a medewe grene, faire floures for to gadre

Be not affrayed thou fairest, thou moste rare, that evere was made! Denye me not a kysse.

Do you mene to overthrowe me? Oute! Allas! I am betrayed!

A man & a yonge mayde that loved a longe tyme, were taken in a frenesye in Myd-sommer pryme.

A creature, for ffetures, I nevere saw a fairer.

Downe satte the shepherde swayn, so sobre & demure.

Hyt was a yonge man that dwelte in a towne. A joly husbonde was hee.

The Turke in linen wrappeth hys hed; the Percien his in lawn.

Com alle youe wantowne wenches that longeth to be in the trade.

As itte bifelle on a someres daye, whan Phebus in hys glorie

Blame not a womman thogh she be lewed & that her faltes be many.

Ich dreemed my love lay in hir bedde; it was my chaunce to taak hir.

Come in, Tom Longetayle, com short hose & rounde, com ffatte guttes & slendre & al to be founde.

Rede me a ridel: What is this you holde in youre honde…

Pardoun, sweete flour of macchles poesye, and fairest budde that evere red rose bar.

Yonder cometh a curteis knyghte, lustily rakyng overe the medewe.

Al in a grene medowe, a ryver rennynge by, I herde a propre mayden bothe waille, wepe and crye.

A deintee duk I chaunce to mete

Ther was a lusti pedlere, and hee cride, "Conyskynnes." And on hys bak he hadde a pak ful of poyntz and pynnes.

Ther was a lasse in Combre-lond, a prettie lass of hye degree.

Me thinketh the poore towne has ben troubled to longe, with Phillis and Cloris in every songe.

Ther was an olde womman lyvede undir a hill. She hadde goode beer and ale for to selle.

I, a tendre yong maide, have ben lovede by many, of al sortes and crafts as ever was any.

As a frere wente along, and porynge in hys book, atte laste he spyed a joly broun wench.

My maistresse is a hyve of bees in yonder floury garden.

I have a tenement to let, I hope wil plese you alle.

In all the world nis a myrier lyfe, thanne is a yong man withoute a wyf.

Goldylocx, joly lusty Goldylocx, a wantoun trikkere is com to toun.

Heer dryveth my ladde along!…We ar the laddes that kan folowe the plough.

He that byeth egges byeth many shelles, but he that byeth goode ale byeth nothyng elles.

Weylawey, that ich ne spanne, whan I to the rynge ran.

To much adulteri doth stille florisshe, as ther in thair delectacioun.

Her name was Alyson that loved noght elles, but evermore to rynge her blakke belles.

I werke on wedes whan moone is on the wane.

Alle nyght by the Rose, Rose, al nighte by the Rose ich lay.

I have a newe gardyn & newe is be-gunne such othere gardyne not undir the sonne.

May no man slepe in youre halle for dogges, madame—for dogges.

To unpraise wommen itte were a schame, for a womman was thy dame.

In every place youe may wel see, wommen be trewe as a brid on a tree.

I have a gentil cok, croweth me daye. He doth my risyng erly, my matins for to seye.

I have 12 oxen that be fayr & broun. They go a-grasing down by the toun.

The fals fox cam unto your croft, and so oure gees ful faste he sought.

The criket and the gras-hoppere wenten heer to fyghte.

It was my chaunce, for to avaunce mi-self not longe a-go.

It dide me goode, to range the woodis, to seke a baren doe.

Heer I was and heere I drank. Farewel, madame, and many thankes.

IV. Wordez & Musique
of Singulartee

Musik and Storyes for to Celebrate Cristemasse

Moevyng Pictoures
The Bisshopes Wife
Myracle on xxxiiij Street
Hyt is a Wondirful Life

Tales
A Cristemesse Memorie
The Verrie Lytel Aungel
The Firste Cristemesse Tree
Fader Crystmas
The Gyfte of the Magi
Howe the "Grinch" Stal Cristesmasse
It Was the Nighte Bifore Cristes maesse
(A Visitacioun fro Seynt Nicholas)

Caroles
Brynge a Torche Jeanette, Isabella
Ich Sawe Thre Shippes
Joye to the Worlde
Herke, the Heraud Angeles Syng
O Lytel Toun of Bethleem
What Childe is This?
Dekke the Halles
O Jhesu Swete, O Jhesu Mylde

O Hooly Night
Awey in a Maunger
O Com, Al Ye Feithfulle
God Reste Ye Merry, Gentilmen
The Holli and the Ivy
We Thre Kynges
Litel Jhesus, Swetely Slepe
O Come, Lytel Childerin
Heere We Com A-Carolynge
Unto Us a Boy Is Y-born
The Twelf Daies of Cristemas
O Howe a Rose Evere Blomynge
O Come, O Com, Emanuel
Angeles We Have Herde on Hye
Rys up, Shepherdes and Folwe
Go Tell It on the Montayne
Silent Night
Hyt Came Upon a Mydnyght Clere
Goode Cristiene Men, Rejoise
Aungeles fro the Realmes of Glorie
The Firste Nowel
O Cristemasse Tree
Goode Kynge Wenceslaus
In the Bleike Myd Wintre
Carole of the Belles

Othere Songis
Lytil Jakke Frost

Hust-a-bye, babee, on the tree toppe

Georgy Porgy, podding and pye, kiste the gerles and made hem crye.

Ba, ba, blak sheepe, have you ony wolle?

Symple Simon mette a pye-man, goinge to the fayre.

"Wher are youe goinge, my prettie maide?"…"A-milkinge, sir," she seide.

Jacke and Jill wente up the hil to fecche a paile of water.

Oon a peny, two a penny, my blak hen, she layth egges for gentilmen.

Ther was a litel man, he had a lytil wyf.

"Com into myn parlour," seide the spither to the flye.

Ride a wode hors to Banbury Cross to se a fyne lady upon a white hors.

If wisshes were horses, al beggeres wolden ryde.

The tyne, tyne spither climbed up the watir spowte.

Lytel Polly Flinders satte among the cindres, warmynge hir prettie toos.

Heere we go a round the mulberie busssh on a colde and frosty morownynge.

As I was goinge to Seinte Yves, I mette a man with sevene wyves.

Ther was an oold womman lyved undir a hille.

"To bedde! To bedde!" seyd Slepy-hed. "Tarie a while," seide Slowe.

If alle the worlde were appel pye, and al the ses were inke

Ding, dong, belle, kitoun is in the welle.

Starre lighte, sterre bryghte, first starre I se to-nyght.

Old Kynge Cole was a merrie oolde soule, and a merie olde sowle was he.

Hickory, dickory, dock! The mous ranne up the clokke.

Polly, putte the ketel on. We wil alle have hot cider. (!)

Ich have a litel shadowe that goth inne and oute wyth mee.

O dere, what kan the mateere be?

Thritty daies hath September, Aprill, Junius, and November.

Kurlyd-lokkes, Kurlyd-lokkes, wiltow be myne?

Roses are rede. Violetes are bloo.

Hote cros bunnes! Hot crosse bunnes!

This litel pigge wente to market; this litil pigge staide home.

Jerry Hall, he was so small, a rat coude ete hym, hatte and alle.

Thre blynde myce, see how they ronne.

Litil Nancy Etticoat, in hir whyte petticote, and hir longe red nose

Londoun Brigge is fallyng doun, falling down, fallinge downe.

Lytel Maistresse Muffet sat upon a tufft etynge hir curdes and whey.

Now ich lay me doune for to slepen.

Mary hadde a litel lambe with fleese as white as snowe.

Jakke Sprat coude ete no fatte. Hys wyf koude ete no lene.

Who is afraied of the bigge badde wolf?

There was a crokid man who walked a croked mile.

Se a pyn and piketh it up; all the dai youe wil have goode luk.

Ringes on hir fingres, belles on her toos

"Oolde womman, oold womman, shal we go a-shering?"

Shyne litel glowerm, glymer, glymyr.

Goosey, goosey, gander, whider dost thou wandre?

Patte-a-cake, patt-a-cake bakeres man.

If al the ses wher oon, what a grete see that wolde be.

Lady brid, lady brid fle awey hom!

Ich have a joly sixe pens to take hom to my wife.

Rayn, reyne go awey. Com ageyn another daye.

Bake me a poddyng. Bake me a pye.

I wol tellen yow a storie of We Johnny Morey.

Ryng a round the rosy, poket ful of poesie

Ther was a litel girl who had a lytel crul right in the middel of hir forheed.

Cok-a-doodle-do! My Dame has loste hir shoo.

This is the hous that Jacke bilt.

Maistress Mary quite contrarie, how doth your gardin growe?

I love lytel kitoun; hir cote is so warme.

Byrddys of a fethere flok togidre, and so wolen pigges and swyn.

Ther was an old womman who lyvede in a shoo.

Susie, lityl Susie, now what is the newis?

Oon misty, moysty morninge, whan cloudy was the wether

I had a litel colt. Hys name was Dappull-Gray.

Peter, Peter meloun eter, hadde a wyfe and ne koude not kepe hir.

Herke, herke! The dogges do berke. Beggers ar comynge to toun.

Tom, Tom, the piperes sone, stal a pigge and awey he ronne.

Bow-wow-wow! Whos dogge art thow?

Oon, two, bokel my shoo. Thre, foure shette the dore.

The world is so ful of a nombre of thynges.

Syng a song of sixe pens, pocket ful of rye.

Ther was an olde man who wolde not seye hys preyeres.

The Queene of Hertes, she made som tartes, al on a somer daye.

Slepe myn childe and pees attende thee, alle thurgh the nighte.

Twynkell, Twinkle, litel starre, how I wondre what youe ar.

Humpty Dumpty satte on a walle.

Here is the chirche; heer is the stepel; opene the dore; se alle the peple!

Thritti whyte horses on a rede hille

Litel Boy Blewe, com blowe your
 horn. The sheepe is in the
 medewe. The cow is in the corn.

The north winde doth blowe, and we
 shall have snow, and what wil
 poure Robin do than?

Salomon Grundy,
 Y-born on Monday,
 Cristened on Tiwesday,
 Maried on Wodnesday,
 Took ille on Thursday,
 Wors on Friday,
 Dyde on Saterday,
 Buryed on Soneday,
 And that is the ende of
 Salomon Grundy.

Mone-daies childe is faire of face.
 Tewes-daies child is ful of grace.
 Wednes-daies childe is fulle of
 wo.
 Thures-daies childe hast fer to
 go.
 Fri-daies childe is lovyng and
 gyvinge.
 Sater-daies child wirketh harde
 for a livinge.
 But the child that is y-born on
 the Sabath dai
 Is prettie and wyse, and goode
 and gay.

What ar lityl boyes made of?
 What are litel boyes made of?
 Frogges and snailes and lityl
 dogges tayles,
 That is what lityl boyes are made
 of.

What are lytel gurles made of?
 What ar litil girlis made of?
 Sugre and spice and every thyng
 nyce.
 That is what litel girles are made
 of.

V. Newe Games with Oold Wordes

Places for To Go

...Babiloyne and Canaan and Nynyve so I wil be a know-it-alle whan I joyn a Bible studie.

...to Londoun, to Londoun to visit the Quene.

...Israel, to ete the foode my Judeish Graun-dame cokes.

...Compostela and Caunterbury to preye at shrines wher, I bileeve, Chaucer preyede.

...Aragon, to see what the "bal-roum," wher my folkes mette, was named after.

...Cornewaile, to see the place of Kynge Arthures birthe.

...Grece, to daunse and brek disshes.

...Pycardie, by-cause I wol have admiracioun for the manye roses, even yf one is not ther.

...Melan, to revel in the taste sensaciouns of Itaille.

...Cana, bicause it wil be the parfit place for my sustres weddynge.

...Oxford, to enquere as to what is special aboute such an olde universite.

...Mount Etna, to see oon of Vulcanes smokynge mountaynes.

...Russye and Norwei, just bycause I know my otter cote is warm ynough, and I boghte newe myttens.

...Egipte, bicause my tykes wil lyke to play with alle that sond, and I wil see the Spinx.

...Cologne, bicause it mooste be fragrant.

...Mount Synay and Galile for Ester vacacioun nexte yeere.

...Athens and Corinthe, to studie the topographie.

...Burgoyne, to rejoyse at the sourse of my favoured wyne.

...Burdeux, to give equal oportunitee to my husbondes favoured wyn.

...Verona, to shedde a teere for Romeo and Juliet.

...Ferrara, to thinke a-boute byynge oon of those famous carres.

...Crete, oonly if I am sure they dide awey wyth the Mynotaur.

...Scot-lond, to gadre enformacioun for a story about a wikked step-dame.

...Britaigne, to telle a travailloures impressioun for the local *Tribune*.

...Troy, to find a carpenter to bilde a large hors of wode.

...Spayne, to observe the incredible spectacle of men rennyng with bulles.

...Brugges, to heere the chirche belles childryn syng a-boute.

...Arabye, to talke to an expert storie teller.

...Boloigne, to compare what I bye to the sausige they make.

...Pisa, to see the towere afore it falles over.

...Lincoln, by cause the fellowes who purloyned my boterflye colleccioun lyve ther, and I am goinge to cacche hem.

...Orleans, bicause I undirstonde it is a grete place to fynde a mayde.

...Castile, to replenyssh our sope.

...Saxonie, to revel wyth som hoom-made sausige, blak bred, and derk beere.

...Flaundres, for a tyme of meditacioun on the popis, rowe on rowe.

...Turkye and Macedoyne, or I may waite for a more pesful tyme.

...Venyse, to chace the pigeounes in fronte of Seint Markes.

...Sisilye, bicause my moder in lawe lyves in Lumbardye.

...Bath, to see for my-self that the watir, forsothe, is hot.

...Perce, to serche for a magyk Percien laumpe.

...Rome, just by cause it is even ooldere than Londoun!

...Paris, to byen a gowne of the newe faciounes.

How Did the Messager Delyver the Message?

...honourably, experly, and completeli as any werreiour fro Scot-lond sholdest.

...cleerly, but indifferentli, scorningly, and oonly to ful-fill his vowe.

...falsly, ferfulli, uncertainli, knowinge that the rysinge of a wikkid constellacioun brought a difficultuous tyme for his wordis.

...demureli, melodiousli, but surrepticiously, while disgised to be allowed to entre the ladyes chambre.

...rigorousli, distinctly, wurd for wurde, to safegarde the warning.

...accidentalli, unwitingli, seminge frenetik. Blesse the lunatik!

...beinge amorous, deinteli, discreteli, while servyng cakes and wyne to all the compaigne.

...gladly, ernestli, mooste conversauntly, to speke of the hoom-comynge.

...supernaturali, celestialli, even universally, and then vanysshed.

...with logik, credibli, and lawefully, while stondynge bolt upright, satchel in hand.

...ingeniousli, irreverently, concupiscentli, as his frendes egged hym [on].

...cruelly, ponderousli, as a mokkerie, while the inspeccioun proceded.

...formalli, benignly, specificalle in obedience with the Popes wisshes.

...as an eves-dropper thought how to taak avauntage of wordis over-herd.

...bitterly, intensli, with some hesitacioun, his garnementes stynkynge of careyne as he spake.

...boldli, effectiveli, corageousli, thogh ther was a swerde at hys bakke.

...attentifli, expediently, ambiciousli, entendynge to geyn favour wyth the Lorde Mayre of Calais.

...obediently, proprelie thoughe forsyd by the lieu-tenaunt to stonde in the reyne.

...pledyng and stamering, with copious teeres, bycause of his compassion for the excommunicate.

...nocturnalli, dolfulli, drerily, under the cressaunt moone at batailles ende.

...ignorauntly, endlessli, tediousli, with much iteracioun and contradiccioun.

...immediately, hastly, wyth impetuosite, havyng arryved after corfew-tyme.

...humbly, devoutli, charitabli, as a report rendered though posthumus.

...blithely, with sinceritie, from the legible duplicate of the muddy epistel.

...impertinentli, riotously, outrageousli, so as to ben outlandissh bifoore his hangynge.

...impatienli, angrily, with arrogaunce bycause his credencial lettre hadde ben douted.

...casuelly and laughingli, to be mysledyng, knowynge he was aboute to be dropped thurgh the trappe dore as a punysshement.

...apperynge hard-herted, and bothe shameful and insolent, in spekynge of the scandalouse parochial matere.

Who/Whatt Is atte the Dore?

...an auncien Affriken Archbisshope

...a bigamus Briton wyth a bugle horn

...a chaste chapelyne in a chariot

...a clever clerk with a cloke

...a cowardly constable from the contree

...a crokke crammed ful of crummes

...a Danish damysell with a daggere

...a dissheveled disciple wyth a dimpel

...a dredful dronken dragoun

...a dusti duchesse relesed from a dungeon

...educatede Edward fro Edinburgh

...an eloquent elf in elevacioun

...an embelysshed, embawmed embassadour

...an entisynge, enamoured enchauntresse

...an erring, erudite (h)erber

...an excited, exiled executour

...a famous, feithful fairye

...a feble, female felon

...fifti fidellers with fidel-stikkes

...a fleshy, flourisshng Flemynge

...a frendly, frownyng frog

...a furious, furre-covered fugitive

...a gander weyring a garlande of garleek

...a gentil genitour werkyng on genealogie

...gidi girles chewynge fryed giblettes

...a glarynge glotoun with gloves

...a goodly goddesse dressed in gossomer

...a gracious Greek grandfadre

...a happy harlot wyth a hamer

...a heretik with hemp for the hermitage

...hired men hyding behinde a hive

...a horrible hostesse redy for homicide

...a hungry hunter in his humiliacioun

...an ille-disposed, ignominious illuminere

...the impressioun of an imperial image

...an indiscrete indigent ful of informacioun

...an irksom, irreverent Irish-man

...a jalous jogelour of Juwerie

...a kindeli king and his kinnes-folk

...a kene keper of a kenelle

...a knelynge knyghte with a knyfe

...a Kristmasse kronikel held by a kirkman

...a large, laughing laborer

...a lecherous ledere of the legioun

...a liberal-thinker who has no lymytacioun on his licour

...a lousi but lovable Londonere

...Lucifer lurkyng wyth a bagge of lucre

...the magistrates malicious mare

...a mercenarie with a merveillous mermayde

...a minstral with a millioun mischefes

...a moevement of motthes toward the mortar

...a multitude of murmurynge Muses

...a naturelly navigable navey

...a nedy, necligent nevew

...nine-and-ninti nightin-gales

...numerous Nubians wyth nutrimentes

...observers who ar obsequious as wel as obtuse

...an oppressour open-mouthed about his opiniounes

...an ordeyned Oriental with ornaments

...an overwhelming overseer eating oystres

...a pacient parisshe patriarch

...a pensif penitent on a pensioun

...a Persien of a perverse persuasioun

...a placable plough-man holdyng a plume

...a practical, thoughe presumptuous, president

...a puffinge publisher in a pulpit

...a quaint queene with a quilt

...a ransakinge rat eating a radishe

...a restrained (Thanke the Lord!) reprehensible revelour

...a riche, rigorous ringere of belles

...a robbere in roial robes

...a rugged-lookyng rustik from Russye

...a sanguin sandal-makere wyth samples

...a scandalouse scripture scoler

...a sensible, sensual serpent

...a shapli shark in the shade

...a short shoppe-kepere shoutinge

...siblinges sittinge under a sicamoure

...a skittish though skilful skinner

...a sloberie, slombering slothe

...a smiling smith smered with oyle

...a sneringe, snoringe snail

...a sombre, solitarie sojourner

...a splendiferous, spekkli sponge

...a squattinge, squeling squire

...a staunch, sted-fast stalione

...a strumpet struglinge with strawberyes

...a subdeakyn whose sustenaunce seems suspecious

...a swine swimminge wyth a swan

...a tanner giving testimony of taxacioun

...a terrestrial terrier markinge his territorie

...a Thuresdai-child thrillede with a thimbil

...a timorous tinker tithinge

...a townman tothles since the tournement

...a trol transporting a trompette

...twinnes werynge twill in the twilighte

...an unhappi uncircumcised underclerk

...the uppermoste usher guilty of usurie

...a viscount in vulgar vestimentz

...a wacche-man whose wages have a warantie

...a weri Welsh wenche

...a wise-man withdrawing from the wilde fir

...wlonke womman-kinde fillid with wonderfulnesse

...x men yerninge to be Zelotes

Different Weyes To Look atte Lyfe

...a fynger in every pye

...with alle due respecte

...getynge even

...rubbe salte in the woundes

...oon dai atte a tyme

...have it youre weye

...not my brotheres kepere

...hed in the clowdes

...to the maner born

...by hook or by croke

...buildynge castelles in the ayr

...destined for the galowes

...centre of attencioun

...shorte and swete

...longe and fruytful

...nothyng but the trouthe

...of doutful significance

...greesse my palme

...the ende justifies the meenes

...livynge in a ffissh bolle

...feith, hope, and charitee

...esy com, esy go

...drynkynge the dregges

...a questioun of moralite

...waitynge for a hande oute

...publisshe or perissh

...devoide of value

...eche day a newe begynnynge

...light-herted, open-handed

...ancle-depe in muck

...winking atte daunger

...obcessed wyth welthe

...goinge to the dogges

...take the bittre with the sweete

...hidynge your lighte undir a busshel

...trustyng the honestie of youre frendes

...obstinateli demandynge more thanne youre share

...circumstaunces biyonde our countrollement

...a nasty, a verray naxty disposicioun

Fro the Yvory Towre

...continuinge laborious studie

...depli committed

...fraternytee hous

...to ech hys owne

...no excepciounes

...latent talents

...a gentilman and a scoler

...cloos-knyt for the future

...eminent lettred tutours

...a tolerable subsidie

...on the tippe of myn tonge

...contradictorie oppiniounes

...dialog and dissencioun

...bete arounde the bussh

...supposicioun out of the bloo

...comunicate with rethorik

...every silable of the silogisme

...recapitulacioun as drye as dust

...habituali ramblynge oute of context

...theologicalli neutral

...quarterli publicacioun

...donaciouns for the librarie

...coveitable folios

... litterature wyth a glosarie

...devouringe obscure bookes

...gramariens glorifying etimologie

...a multitude of synonemez

...prayse worthy pamphilettz

...pinche-peni regentes

...a surfeit of memorandes

...numerous endowements

...doutyng the claimed antiquite

...leuk-warm reaccioun to the projecte

...fervour for physik and astronomye

...permutaciounes and combinaciounes (!)

...theoretical eqwalyte for men and wommen

...contributions of the ever necessarie patroun

...an altercacioun bitwene the authour and his scribe

...maligned by the townshipe every nowe and thanne

A Cause for Speculacioun

...the depthe of a spelunk, a caverne

...thynges that sprynge up lyk a mussherum

...beinge transformed by a brefe encountre

...esteme for a Verray Important Persone

...the magnificent firmament above us

...bright coloured plumage of pecokkes

...the re-birthe of the ffenix

...oure confidence in dai-light on the morowe

...strengthe and inspiracioun fro a fewe wordis

...the powere of a winninge smile

...the flyghte of a flokk of pelicans

...occultacioun of a planete or a parcial eclipse

...great dismay by-cause of a famous relatif

...trewely Alceoun dayes

...watir fallynge fro a clyffe

...cragges of a baren summite

...an amyable Amazon nacion

...the influence of a gleminge comet

...a splendiferous festival pageant

...day dremyng a-boute rustelinge taffata

...spontaneus combustioun (!)

...constellaciouns sparklynge thurghout the firmament

...understondynge fracciouns and equacions (!)

...the Incarnacioun

A Daye in a Court of Law

...the evasion of "as ferre as ich knowe"

...the accions potraiinge cause and effect

...shakkeled and accused of a dedli stabbe in the bak

...sequestryd in an erly sessioun

...grasping at strawes to fynde the myssynge persouns

...divulgid to the jugge in his chambres

...siftynge the evidence in the recorded transcript

...answeres recognised as a pak of lyes

...a conspiring go-bitwene thynkinge oonly of moneye

...gilty of manslaughtre with no apparent motyf

...sobbynge hir herte oute oon more tyme

...a weghti problem for deliberacioun by the Chefe Justicez

...secunde thoghtes while in the pillorie

...the assaut of an assailour from out of the schadowes

...remorse over the demandes of restitucioun

...takynge a milioun to oon chaunce

...tremblynge in anticipacioun of the galowes

...fynderes keperes, losers wepers

...sorowe bicause of the damage

...a pompous jugge who loketh doun his nose

...You coude here a pyn droppe.

...testimonie as cleere as mudde

...the liklihode of beinge in hote watir

...the frustracioun of eting humble pye

...can not maken hede or tayle of the sub-pena

...a defendaunt bitwene the devel and the depe blewe see

...no laughing matere, now-a-dayes

...profitable for criminal lawyeres

...jugge and jurie in the jurisdiccioun of the metropolis

...broghte forth a stronge disputyng argument

...afflicted by repeticioun of the awkeward situacioun

...a wyf with a perpetuelli forowed brouwe

...presumed innocent, in the mene-time

...to distraught for secounde gessing

...taak refuge in the frigid forest for a tyme

...plight of the bablyng chamberleyn

...drewe nygh, mene-while, and recited the othe

...repelled bi the opposicioun expressed

...private reparaciouns required of the brotheres fro Saxonie

...banysshed from the negociacion bicause his hed was balled

...consequences of the benignytee of the apoynted advocat

...understondynge the habeas corpus jargon

...no suffisaunt proteccioun of the perimetre

...revyled by the militari garisoun for trecherye

...graunted the plaintif utmoste supporte

...a malefactour yearnyng for the aforesaid intermissioun

68

...corroboracioun of evydence of badde feelynges

...a five-minute publik confessioun, and a semblance of contricioun

...attemptinge to comprehende the attournei fro Hungari

...relinquysshed the right to live in the Neapolitan territorie

...withholding credence for the accusacioun of the lok-smith

...trikked by the extravagant flaterye of hir newely wedded spouse

...verified by perjurie from a physicien of venerable reputacioun

...an exhumed body y-thud to the flor

...biholden, undir duresse, to a Duche uncle

...a nappinge alderman clucchynge his almenak

...overturned the creditours decisioun

...a resigned shrugge of the scholdres for the verdict

In the Gardyn

...a liserd crepinge among the fern

...holi-hokks neer the hous

...brighte colours of nasturcium and portulaca

...newis herd by the grape vyne

...youres trewely hangynge up the wind chymbes

...a retournynge pijoun festinge on gnattes and grubbes

...a semicirculer walle of stonys

...Aprille pervinkles and columbine

...a cristal edifice, an abode for larkes and wrennes

...flittinge and twyterynge that signal the approche of day

...idemptical twinnes plauntinge many pancyes arounde the pavilion

...a dent-de-lioun growyng amidde the dayesies and marigoldes

...neer the fountaine, fragrant percely, sage, rose-mari, and tyme

...and the usual erewygges and snails

Thoughts of Gestes at a Weddynge

...falle hede over heels

...a weddyng invitacioun

...heer cometh the bryde

...shepishe youthe

...a wommanli delite

...elegancy of hir tresses

...visual titillacioune

...observinge fro bynethe hir vayle

...walkyng on clouds

...my suster-in-lawe

...resembleth hir modir

...coste a praty peny

...in over his hed

...another matere entierly

...a home in the suburbes

...yerli progenie

...countyng nyne monthes

...a secret chambre

...and so to bedde

...yonge and willyng

...a sterne cleric

...a sot of a sacristan

...childeren scatered floures

...powerfull organ

...sweyinge chandelier

...a dor-mouse neer the screne

...love, honour, and obeie

...alle his worldly goodes

...fro this dai forward

...consummacioun a prioritie

...my coussyns excluded

...oonly tyme wil telle

...in name oonly

...so ferre, so goode

...heve a sighe of relief

...for goodnesse sake

...desirable parteners

...provyde nocturnal distraccioun

...warm the cockilles of my herte

...somme thynge speciall

...housbonde and wif embracing

...a kiss for her gentilnesse

...beste frendes

He Thinketh Aboute

...talle and streight as an arowe

...beinge selfe-willed signified by a prominent chin

...lene, lank and hard as nayles

...the boldnesse to finish hys labours

...seise the bole by the hornes

...embolden by girdynge thy loynes

...hange oon on aftir moderes departure

...a culpable habyt of strecchynge the trouthe

...a luxurious, private swimming place

...rechinge the fynissch lyne withoute delay

...beinge destructive to the enemy

...a wynne, winne situacioun

...bigge fissh in a smal ponde

...a monthes vacacioun in Normandie

...the nocioun of revenging the torment of the holocaust

...rescouinge the Ethiopien hostages withoute an injurie

...in lyk flynt a fore-gon conclusioun

...his gurguling inwards calling for foode

...surloin of beeff at a sumptuous mele

...gronynge wyth the added hevinesse of his paunche

...nevere no gras to growe under his fete

...blowe your owene horn

...winninge a lucratif champioun chief macche

...finalli havinge bothe feete on the grounde

...dependaunt upon bryngynge home the bacoun

...the stresse of winner taketh alle

...a fether-bed for the envied bacheler

...frustracioun of sensualitee whetted by ymaginacioun

...the nebulous embrace of a voluptuous enchauntresse

...a noughti nymphe tiklyng your toos

...Oedipus-like thoghtes suppressed

...just a gigelot sowynge wilde otes

...prone to the wiles of petite pulchritude

...bound and determined to create the opportunite

...the finesse of smothe talke ledynge to a conqueste

...assumpcioun of a subsequent penetracioun

...askyng permissioun to declare his love for Clotilda

About Werke and Werkeris

...Gyff me a breke!

...bragginge or compleynynge?

...a frustrat spinnister spinnynge flax

...hitte the nayle on the heed to fabricate the enclosure

...covertli rescouinge the damagyd statue fro the fornace

...the abilite to restore the flowe of watir

...the vexacioun of goinge bakke to square oon

...hindringe the hous-wyf fro gettinge into the swingen

...a talowe chaundeler with a hoole newe bal of wex

...a grocer with a grosse of spycez and divers warez

...the glazier geten a handel on itte

...scrapinge the fleute cleen as a whistle

...have an ax to grynde in spite of the residue of resin on the grind-ston

...the uniformite of the whele-wrightes produccioun

...the juweleres applicacioun of enamel to the gold at youre biheste

...a ffeasable moeve whil oute on a sturdi lim

...not to blame for stumblinge wyth the sculpture of the gargoile

...reputacion as a skilful fleccher

...reconsile the rancor in a salarie dispuit in parlement

...werk youre fingres to the bon atte pecemele

...malt, barly, and whete fermentyng for the brewer

...a vintner yelling bi-cause of the thefte of the gallon

71

...a newe aproche to the probleme of weikned construccioun

...a secretarie sekynge securite & equal emploien

...a preferred weke-dai occupacioun

...som thyng of value atte a fixed prys

...a lastynge impressioun of qualite countrollment

...struglyng craftesman with a tampon for to clense the pipe

...ternyssh the silver kuttynge egge

...a grievous errour in multiplicacioun of binarie nombres

...daunted by the dyametre of the cercle of trees to cutte downe

...a motli crue with bygynneres luk werkyng in slowe mocioun

...many trustful servauntz and oon mayde wyth miserable maneres

...the cobleres materials replenysshed

...to activeli participat in the demonstracioun

...no utilite what-so-evere in this inconvenient methode

...elacioun caused by the descripcioun of the comynge vacacioun

...a correccioun in the coste bycause of the damage

...fallyng fro the bakhalf of the scaffold as al in a dayes werke

...dismal men for grevaunce committees

...an apothecarie who combines arsenik, asshes, and poudred accornes

...the constable disfigured by the flambes of the fyr

...a disagreable assignement now, a nuisaunce afterwards

...a slumberynge couper snoren by his barels

...alienacioun of hys servauntz: butiller, bakere, and cooke

In Batel

...awaitynge the comande "over the toppe"

...crowdyng bitwene a rokke and a harde place

...the quarter-maistre recognised bicause of hys bagges

...a shot fro ship–bord to shore

...an odious busard that hovered above the devastation

...the dredful heritage of folowe the ledere

...a wery wrecche dashing toward the monument

...interminabli wacchful for oon fals moeve

...the dishonour of fikelnesse in regard to alligeaunce

...ordres enforced by gunne-powder

...signes of lyf when a sonne-bem perced the smoke

...blood triklyng on to the turf from a hideous wound attracting flies

...loste vital strengthe and was ded on arivaille

...pressure to releeve perilouse grete bledinge

...maimed by a savage knyfe slasche

...provisioun for an artificiall lym

...a vulture cercling the desolacioun

...vehement opposicioun to prolongacioun of the seege

Sowndis to Heere

...a babee snese

...a remote quire

...a water-fal

...secound fidel

...innocent laughter

...dissonaunt cordis

..."It is a boye!"

...talke of the towne

..."It is a gerl!"

...gingling jeuelrie

...Stoppe the musik!

...a loud thonder-clappe

...a balade perfourmed

...lyvely tympanie

...quiete in the noricerie

...pleiyng musical chaieres

...a rabbi chauntyng

...poetrie to goode for rabel

...a melodious vocal reprise

...whispring sweete nothynges

...lulled to slepe by lute music

...a shrille, squelynge bagpipe

...the clamour of games childeren pleye

...plukke the strenges of a gitterne

...an introduccioun to excityng musik

...notificacioun of wynnynge the prise

...a chorys of childryn singing in a chapel

...the reverberacioun of a trumpet in a halle

...a mydnyght conversacioun with the persoun you love

In the Spring of the Yeer

...cole as a cucumbre

...a bicche noselynge hir yonge

...youre blosmy orchard in the valeye

...crocus and fox-glove in Aperill

...primroses biside the path

...a lambkin to monche on the blossoms

...a felynge of beinge fild to the brymme

...fressh hony and honycombes

...come helle or hye watir

...frequent momentes of reverie

...to nyp it in the budde

...couples, two-by-two, hand-in-hand

...a pilowe fild with blosmes of lilies of the valey and affodils

She Thynketh A-boute

...dyamaunt in the rough

...eyen lik sterres, teeth lyk perles

...a fabulous unblemished face

...byg as a hous, but witti

...sprynge fevere and swete xvj

...pamperyd in castels in the ayr

...light as a fethere nexte yeere

...smothe as silk, happili ever after

...It will crull your heer.

...a luxurious bobel bath

...insaciable craving for sugred roses

...redy, willing, able and eligible

...on pynnes and nedles

...touche and go

...cacche as cacche kan

...talle, derk, hondsom, and suave

...a riche galaunt

...rede hym like a book

...an excityng love interest

...affeccioun for an apprentice

...taken by delicat conversacioun

...the blush of her firste kis

...overcome bi the aromatik aura

...quenche the passioun of pursuit

...a frok throwen in the corner

...straunge bed-felaues

...loved not wisely but to wel

...the morwenynge after

...been ther, doon that

...studie oure tre of auncestres

...a vocacioun to live for

...wacching a babee slepe

...cherub holdynge an unborn childe

...kepe the hom fyres brennyng

...hennes-forth oonly trewe love

...fro the botme of myn herte

...no recluse, fewere requisites

...tikled to deth

...statli in hir slevelesse gowne

...a tuk at the waist & a corset

In Hir Purs

...hir spittyng ymage

...a brusshe and coomb

...a paire of sheres

...a skein of thred

...a cloth for enbroiderie

...a bagge of coper coynes

...a coughe losenge

...a smal whyte kerchefe

...two boyled eggez

...a bunne

...and, secretli, a ded crykette

Oold Folkes Thynke Abouten

...Wole wondres never cese!

...figment of ones upon a tyme

...pacified and born agayn

74

...hevene oonly knoweth

...divulgid a familie secret

...spitefulle siblyng hostilite

...personal prescripcioun for triacle

...pressyd for tyme to make amendes

...regretten errours in juggement

...pouryng oille on troubled watres

...liberacion, gon to his rewarde

...snuffid in the twynkelyng of an eie

...forfeited my hoom

...a smal comfortable habitacioun

...no spare roum or couche

...oonly a dresser, shelfe, and bed

...annoyance over custody given

...parting fro an object of affeccioun

...clothes of thredbare worstede

... a medlynge sone-in-lawe

...banysshed fro the kichen

...gruel and liquified foode

...a nooke quiete as a tombe

...to be content over the hil

...come fulle cercle, cradel to grave

...senior citisein segregat

...oonly this particuler poynt in tyme

...outlived alle the cosyns

...on borwed tyme

...a mys-aventure turned happy

...to gyve a litel free avys

...quit-claime fulfillynge a promisse

...consolacioun of a dreme illusioun

...fore-boding of deminished
 facultees

...a resident unable to exercise

...a wisp of my former selfe

...babee steppes, no stride

...taciturne in delusiones

...slepyng wyth gapyng mouthe

...ashamed of glob on floor

...a scoldyng and dejeccioun

...a lump, terminal atte laste

...consent to notifie the nexte of kyn

...demaundyng deth with dignitee

...sixe feet undir with an epitaffe

...alle in the same bote for the
 duracioun

...a love that outlasts oure finit lyfe

...responsive to a weddynge
 anniversarie

...a glas of cold beer, fild to the
 brymme

In Chirche

...God blesse yow!

...a donoures huge marbul statue

...obligacioun to tradicion

...a relik transferred by an abbesse

...welcominge a reformed robber

...a neophite wyth hat in hond

...the talkative upper cruste

...inperfecciounes sene in otheres

...acolites participating in bakbityng

...praiyng a letanie alle by mi-self

...resignacioun of the subordinate

...nominacioun of a successour

...announce the annuel rafle

...a miraclous heelynge disclosed

...edifiyng preyeres at benediccioun

...expulsioun of a druncard in the loft

...condempninge fornicacioun and glotonye

...the graciousnesse to for-give and forgete

...a mellifluous motet at the candel lyghte vigil servyce

...orisons of the prelate in resplendent robes

...a permanent deaken preching the omelie

...belevers assembled for the baptesme of the old chandeler

...pesfulli slepyng thurgh a fyr and brymstoon sermon

...an inquisicioun aboute notable defaultes for reformacyon

...a drery contemplacioun on deth and the corrupucioun of the body

...a quarrel betwixt the preeste and the quire at evensong

...the destourbyne salutacioun of an ypocrite

...a suggestioun of topikes for the covenaunt

...werkyng in the sacristie as a meenes of expiacioun

...the governesses veneracioun of the holi sacrament, the eukarist

...Cristyanyte yivinge credence to the Transfiguracioun

...(not for al the worlde!)

Concerninge Domesday

...That wil be the dai!

...Bettre beleve it!

...God forbed!

...baptesme by fyr

...ete youre herte oute

...erthe drawyng to a close

...fundamental to Cristendome

...stedefast durynge tribulacioun

...blood, swette, and teeres

...exhorting repentaunce

...sufferynge seure as helle

...in accordaunce with the sermon

...for uncountabulle generaciounes

...domesday fillyng thare myndes

...conseillours disputyng a texte

...expoundyng obstacles to absolucioun

...a congregacioun presuming martirdom

Thynkynge of the Occean

...any port in a storme

...watir under the brigge

...the westerne skye yondre

...the oon that gat awey

...lepynge sword-fish and porpos

...a siren reclyninge on the rokke

...a sandi shore at loweste ebbe

...a cork bobbyng uppe and doun

...a glisninge, tranquil sea

...wo-bigon withouten fresshe watir

...the marineres lyf of privacioun

...shipwrak with ne rodyr ne saille

...shippes of Brittish registri

...an anker rope entangled

...dank withinne the vessel

...struglyng wyth damaged oores

...a pumpe gushing watir bak oute

...bathing appareil

...The Emeraude Ile

...sailloures wrekynge havok

...monstres in the mirki depe

...the songge of a mermayde

...an armes-lengthe bitwene, as the admiralte directed

...a hevy swerde penetrating the corps, and plunginge it into the oceane

Wicches, Warlockes and Suche

...Thank youre lukki sterres!

...climbed the temple pinnacle at mydnight

...descending into the crevice and skerrid stif

...the snarl of a pantinge leopard

...experimentez & incantacionz & charmez

...a hastie ceremonie, olde as the hilles

...bon-fires for the solstice of yesternight

...can not calle youre soule your owne

...youling dogges and a newe-comere as stif as a bord

...apprehension due to feere of the depe, narow sepulcre

...an owles voys, as lucke wolde have it

...desguysed, hir face concelid by a blakke veyl

...a glade where a foul tode was blowynge bobeles

...a sponge sokinge in putrid liquid

...a heynous sacrilege, a rite of sorcerie

...a kidde blak as col sceduled for slaughter

...a sorceresse lakkynge the essencial solucioun

...a smal hamper conteining rusti nayles, a hors-sho, and a wex tablet

...beinge destined for perdicioun makyng hym turne in hys grave

...thret of infinite mutaciounes bycause of the malediccioun

...vileyne setting the convent a-fyre with bundeled twigges at the equinox

...his wilful digressioun a distraccioun fro the secret of the laberinthe

...the prophete dismembrynge the doves in heremytes cave

...the turd of a turtle and the bon of a bicche in a transparente urne

...angwisshe created by the wrdes of the augurer, as fate wolde have it

...the magicien cursinge the cow and calf and hogge

...only a simulacioun of walkynge on air

...a warloghe sprenklinge a fomy fluid into the crusible

...a scribe translatynge the scribbled Hebraik inscripcioun

...prophecies of the astrologer recordede with an ostriche-fether quil

In Somer

...as good as hyt geteth

...abundaunce as the crowe flieth

...kuttynge and raking, wedyng and mowyng

...a picche-fork to werk the soil

...pultrye on the porche, rabettes on the roof

...a sicamour nexte to the somer-hous

...fragrant lavender neer the gate

...lilies, irisis, and popies on the ryver bank

...gladiols menglid among the roses

...bendyng lymmes, hevy with fruit

...etyng the fruites of somer

...a ferret tastyng what he wil

...a quadrangle shaded by elmes and hawethornes

...another syde of warm sonni daies

...rotted, sonne-bleched cloth

...a trough for glotenish swine

...the sikenynge stench of alle the robishe

...scume and slime on the schalowe ponde

Feeld and Forest

...This is the lyfe!

...beste of al possible worldes

...can not see the forest for the trees

...oure fethered frendes gretyng the first light of day

...a grove of vermilioun sumacs

...a quiet rural regioun neer a streme wher fisch ar spawnynge

...nets used in cacchyng smelte for to frye

...colleccioun of sap fro the maple trees for sirop

...toilen wyth sikeles in a feelde of barly

...reverent anticipacioun of midday chimes

...the schimeringe reflectyng in the lake

...hoom to salomandre and quail and a swarm of locuste

...injurie to a beares snowte

...an ekko of wilde gees in the distaunce

...a rootless honysoukle withering on the path

...youre cloke covered with thisteles and netles

...a lodge on the knoll makyng preparacioun for the huntyng seson

...whininge dogges with wagginge tayles, an awe-enspiring sighte

...the hors wyth the goode trot curryed

...pursuing elke for to maken a roste

...pik and shovel and hachet

...the shrubbes hakked and tramplid

...attempting to eradicate the pol-cattes from the seccion

...his palm perced by a single, slendre tusk

...no agrement about the bayte for the trappe

...hordes of vermin tumblynge into the dich

...oon goos bryngyng satisfaccioun to bothe the slye fox and the wily wolf

Lif with Roialtee

...born to the purpul

...oure furre clad bettres

...Pardoun my Frenssh!

...nothyng but the beste

...perpetuel palace concubine

...willynge servitude

...obeien a treccherous tyraunt

...an iren fist in a veluet glove

...a pad-lok on the tresour

...constant personal proteccioun

...renounced the kingdom

...a shotte in the derke

...foreyne and domestic discord

...stablisshed sanxiones

...fraudulent plegge of allegeaunce

...a dukes repeted indiscrecioums

...pomp and ostentacioun

...a spacious warde-robe

...spotles raiment

...exemplifie sophisticacioun

...carying a smal prik-ered dogge

...concerninge materes of consanguinite

...born with a silver spoon in his mowthe

...amblyng toward clensyng abluciouns

...dwellynge prosperousli ammyde the famyne

...transcendent devocioun to the emperour

...her diademe visible thurgh the gossomer curtein

...curiositee a-boute what was by-nethe her qwisshin

...coronacioun robes of satyn, veluet, and ermin

...jeuelrie of diamauntz and emeraudes and rubies

...a proposed journee to Russye and Turkeye

79

…an antheme proclaimed by the assemblee of vassalles

…the celestial revolucion predestininge unreste rather than unitee

…an autentik successour awaityng the signal amidde the throng

…the frownynge contenance of the empresse as shee observede hir accusours

In the Face of an Oppressour

…fighte tooth and naille for libertee

…with youre bak to the wall

…stoppe at nothyng

…an ere to the grounde

…a noble caus mocked

…soule rending tragedie

…a grymme out cominge

…vicious persecucioun

…passive resistence against hem

…gave tribute for the sake of pees

…signed the degrading tretee

…deceitful embassadour

…provokynge foolhardy accioun

…tragedie of the skirmisshe

…traitours licenced to kille

…helde hostage wyth crueltee

…familyes langwisshyng in prisoun

…purgatory, roughly spekynge

…scarseli ete like a brid

…a listles basket cas

…hys quilte made of ragges

…prescribed distribucioun of cole

…difficultee of administracioun

…rumours of rebels and treison

…unbridled desparacioun of slaves

…depopulacioun of the rural poore

…tribulacioun amonge the enprisoned

…affrayed of youre owne shadowe

…contynuacion of hir distresse

…prostrate in apparent submyssioun

…her torne, unclene garnementes

…angwissh dissolving into oblivioun

…lamentacioun of destitute widowes

…fiersli resisted duryinge the hostilitie

…overcome by the bestialite of the barbarians

…reconisaunce bryngynge considerable reward

…refusel, not withstondinge angre of the viryl adversarie

…mankynde beinge tolde to submitte to everlasting distresse

Passen Thurgh the Strete

…never a dulle moment

…a druncard stagerynge on stiltes

…a catte out in the colde

…drasty goter language

…an utterly repugnaunt rustik

...ne knowen him from Adam

...marchandise loste yisterday

...a gerl syngyng a familier ditee

...a noiseful taverne braul

...rudenesse of a scoulynge slutte

...an odour that offendeth

...a boy struglinge with a hound

...a tatered, unshaven wanderere

...an oolde crone in hir nyght-cappe

...a lepre, gawnt and neer deth

...a mendicaunt dreme-reder

...reyninge cattes and dogges

...a free for alle in the mire

...accidentes happe duryng a chace

...thikke as condemned theves

...hye as a kyte bi the pilfre of wyn

...private entraunce of a brothel

...a lark for sale on a perch

...selling hand-tamed crowes

...a lanterne in the wyndow

...a humbil pedeler fro Polain

...a tumbler jogeling tenis ballys

...wayward boys who siphon beere

...cowre lyke wet-shod beggers

...rawe mete and crustis of bred wyth moulde

...marchandise weyed with a balaunce

...the stelth of a pykepurse gleninge sufficient for the day

...an advertisement as a protestacioun ageyns diffamacioun of a writere

Childeren Thinken Aboute

...chippe from the old blocke

...brighte as a peny

...growyng like a wede

...a face oonly a mooder coude love

...fulle of benes

...a feble respounse

...writing lyk hen-cracche

...struglyng with mathematique

...multiplcacioun, extraccion of rotes

...dyvisioun, divisoures, & quocientes

...geometrie like-wise

...knowynge the correcte answere

...putte on youre thinkinge cappe

...inspired to do bettre

...love for the scole-maistresse

...a lecture on metre and rime

...writing the beste poetrie of alle

...graduacion dai

...eche wekes allowaunce

...refused to fecche the sakke

...in the dogge-hous again

...cocodril teares

...spille the benes

...alle thumbes

...begging pardoun

..."not in front of the childerin"

..."Seye youre prayeres."

..."Ete youre vegitables."

..."No roughe stuffe!"

...clymbyng highest in a tree

...frighted by a violent storme

...shakinge, quakinge at the thondre

...discovering a caverne of his owne

...in the armes of Morpheus

...sweete dremes

...not aqueynted wyth animals of the antartik

...insolent truaunts hyding in a cisterne

...adolescentis in processioun for the synagog ritual

...too byg for hys breeches, but not for longe

...licorice

For Cristmasse Giftes

...mannes beste frend

...the prys of admissioun

...warme wollen blanket

...cristalline heir-lome

...a Cristemas sugre-lof

...coral pendaunt

...downe fild jaket

...strond of perles

...newe-made peche gelly

...red felt cappe

...hevy flannel shirt

...bloo satin slippers

...a powche with tassels

...name lefte blauncke

...penne-knif for junior

...ratelle for babee

...a sable cote

...ffilbertis in sugre-candi

...giftes hidded in the closet

...noveltees made by a potter

...gold, frank-encens, and myrre

...an extravagant nek-ker-chefe

...bootes of cordewain lether

...a bettre penne, ful of ynke

...a handi-dandi bowe and arowe

...coloured penselis and paper

...gold tisshue clooth for a gowne

...our auncestres yvory handwerk

...a riche broche, with a cluster of saphires

...an autentik fourtenthe centurie manual, juste descovered

Som-thyng Dereli Wisshed For

...rollynge in moneye

...a wigeling newe borne

...have your cake and ete it

...lyvyng in the lappe of luxurie

...a musiciens naturel abilite

...YOURE openyng nyght

...tapestrie of many colours

...the blessynge of refrigeracion

...to slepe like a babee

...a pece of the accioun

...som thing to shoute a-boute

...a dreeme com trewe

...beinge maried to a lapidarie

...fulfillynge a lyf-longe ambicioun

...slepe after a longe, difficult daye

...a free meyntenaunce contract (!)

...the designacioun as chieftayn

...a simple blak suit wyth a slit skirt

...a favourable phisiciens reporte

...a biloved dogge livynge twenti
yeeres

...a grouchinge retaillour with youre
refund

...seing girles skippinge with hoops
and stikkes

...lying in the sonne as the
occupacioun for the daye

...hateful peple gettyng pye in the
face

Thynges to Avoide

...the stynge of a wasp

...altitude siknesse, if possible

...a libacioun of hemlok

...beinge pakked in lyk sardins

...havying to hot-fot to escape

...opposicioun to exercise

...a stuborn pedante

...a conflict of interests

...contrefete moneye

...fatal attraccioun to a lover

...beinge youre owne werste enemy

...a schatered mirrour

...dongeons and dragounes

...wikked, contryving adminisratours

...acceptyng a poure imitacioun

...visitynge a filthi dwellynge

...garbage of 10 dayes stondynge

...to muche, to soone

...walkynge on thinne yse

...a large box of livelie squirelles

...the deluge of a broken pisse-pot

...byinge a drouping violette plaunte

...pursuinge a snake as it slynkes
awey

...wringing a garnement that wil
wrinkel

...an irascible hagge wyth her hand
oute

...beinge unable to resist a bak-ward
look

...youre thombe smogynge a rubrik
in a book

...a bere findyng a holowe tree fillid
with hony

...being surprised by a fatte ele in
your bath

...not seing beyonde the ende of
youre nose

...beinge a distraccion by whistlynge
duringe a copulacioun

...beinge foolissh ynough to tese a
threteninge scorpioun

VI. Foode: the Centre of Eche Day

In the Scullerie

...carying boketes of watir

...alle the clenyng and choppyng

...a sculyon scouryng gredils

...a stak of skellets to make clene

...greesse on many pannes

...scorched pottes sokynge

...spatule and many utensilementes

...faces smered with grece

...Hoppe to it!

In the Kichene & Bake-hous

...hye and drye and warm as tost

...the smel of bacoun and eggez

...find neither hyde nor heer

...refusyng poore substitutes

...bigger fisshe to frye

...cod, makerel, and flounder

...gravey and beef blod

...beof tonge and marow

...larding the venisoun to roste

...resyns, peres, quince, and dates

...rejectyng fruyt roten to the core

...a fyne ketel of fissh

...stemyng ketels to kepe a lid on

...pottes too hot to handle

...a fragment of shelle in the batour for to frye

...the fragrance of notemuge and cinamome

...questiounyng the qualite of the surplus fissh

...a ladel in the caldron over the smolderen of the fyr

...halfe baked foodes

...knedyng-tubbes for bred dowgh

...soure doghe and yest

...carewey, fenel, and spicerie

...a scoope for fflour

...bynnes in the pantrie

...oon binne for bred

...a wee timorous mouce

...a skulkynge reptile

...whelpes sniffen aboute the oven

...the baxter (bakester) shaping eche lof: wheten, barli, or ry

...wacchyng for fetheres from sparowes in the rafters

An Array of Foodes

...plateres of samon (do oute the bones) wyth cinamome and clove

...a legge of mouton with grapes and gingere

85

...rosted hede of a bore

...baked heryng

...loyn of pork, rosted wel

...a crustarde in the oven

...fyssh, egges, walnottes, saffron, and herbes baked in a crust

...mete scored and redy to roste

...a pigge on an iren spit

...(cookes knave turnyng the spytte)

...the perboiled brayne of a swyne

...pork brayn with yolkes of egges, to frye in whyte grece

...sawces flavoured with roses or strawberyes or violettes

...baked stuffed pastree castels served forth wyth flaumbes

...a fritur of sugre, almandes, and bred grounde togedre—
adde egges
fryed in grece or oyle
florisshed with grete plentee of crymsin kernels pomme-garnets

...gilded and silvered images of sugre, almondis, and egges cast in moldes

For Clene Handes

...a basyn

...a pycher of watir

...sope

...and a towelle

Thoghtes A-boute the Foode

...have it at youre fingres endes

...lyve hand-to-mouth

...salte of the erthe

...have a bon to pike

...an exhibicioun of good appetit

...a babee pouting and spittyng

Sett the Tabyll

...a cloth to spredde

...nappekins (cotoun or linen)

...plates

...cuppes

...tankards

...silver goblettes

...bolles

...forkes

...knyves

...spoones

...saucers for the sauce

...and salt cellaris

...mylk

...butre, fresshe fro the chyrne

...chese

...vynegre and oyle

...cidre

...ale

...botels of wyn, whyte or red

...ote-mele (for the babee)

Serven Forth the Foode

...som-thyng for everichon

...thikke pese soupe

...grete bolle of asperages

...turnepez or spinach

...a small bolle of rubarb

...letuce, water-cresse & vinagrate

...pipyng hote wafres

...distributen hot barly bred

...savory stuwe in a pot

...tendre veel & rys in crem sawce

...pekokes or malardes

...partriches or swan

...stuffe samon, sturgeon, or crabbe

...broiled scalopes with mynced oynouns & lekes, and vinegre

...a basket fillid wyth blakeberyes

...a dysshe of strawberyes and creme

...ripe plumen, withoute stones

...gulpinge, qwikly slakinge his thurst

...enbibynge another favoured beverage

...rechinge the botme of the barel

...a bakeres ymaginatif creaciounes

Today, Mayhap

...a meel of soupe and salade

...refusen onyons and garlik

...foode for thoughte

...a balaunced diete

...everythyng fro soupe to nuttes

...thenne and nowe, the scrappes for the dogges—the spaniels, terriers, mastifs, grehoundes, and manie othere houndes

The Twenti Thyrde Psalm

The Psalm whiche the
Kynge James Bible nombreth 23:

The Lord gouerneth me, and no thing to me shal lacke; in the place of pasture there he hath set me. Ouer watir of fulfilling he nurshide me; he conuertide my soule. He ledde me forth on the pathis of rightfulnesse; for his name. For whi though Y schal go in the myddis of the shadewe of deth; Y shal not dreden euelis, for thou art with me. Thi yerde and thy staf; tho han confortid me. Thou hast maad redi a bord in my sighte; agayns hem that troblen me. Thou hast muche fattid myn hed with oyle; and my chalis, fillinge greetli, how ryght cler it is. And thi merci shal vnderfolewe me; alle the dayes of my lif. And that Y dwelle in the hows of the Lord; in to the lengthe of dayis.

The lyf so short, the craft so long to lerne.

—Geoffrey Chaucer, *The Parlement of Foules*

Also by Dolores L. Cullen—

Chaucer's Host:
Up-So-Doun

"Written to be immediately accessible to the non-specialist general reader, Cullen's new insight will compel significant reassessment within the scholarly community of Chaucer studies."

—*Midwest Book Review*

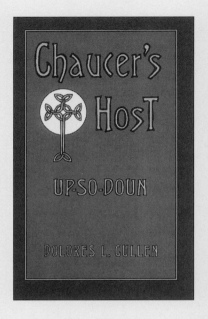

Innkeeper Herry Bailly is the host of the company who tell and hear Geoffrey Chaucer's *The Canterbury Tales*. For those who simply enjoy the entertainment of storytelling, that's all he is. But read between the lines, and find the allegories embedded in these tales (as Chaucer's contemporaries were accustomed to do), and you'll find the image of Christ—the central force and guiding light in Chaucer's plan of literary pilgrimage.

ISBN 1-56474-254-7
Paperback $14.95

For further information or to order this book, contact
Fithian Press
Post Office Box 1525
Santa Barbara, CA 93192

to order by phone: (800) 662-8351
www.danielpublishing.com

Also by Dolores L. Cullen—

Pilgrim Chaucer:
Center Stage

"Dolores Cullen's work on Chaucer offers
some consolation to those who feel that
Chaucer scholarship has become too
specialized, too arcane....Cullen makes
an interesting discursive intervention into
a field that is normally dominated by
specialists."

—*The Medieval Review*

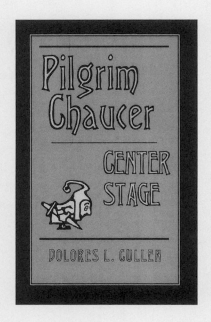

Dolores Cullen, an iconoclastic scholar with something new to add to centuries
of medieval studies, examined the religious side of Chaucer in her first book,
Chaucer's Host: Up-So-Doun, in which she identified the Host of the Tabard with
Christ, the Eucharistic Host. Now Cullen turns her probing mind to Chaucer's
bawdy side, identifying the poet's own history of scandal and sexual misconduct
with the tale of "Sir Thopas," which he offers at the behest of the Host. "Rather
than turn a blind eye," Cullen writes, "I see the poet as a man, not an icon."

ISBN 1-56474-306-3
paperback $14.95

For further information or to order this book, contact
Fithian Press
Post Office Box 1525
Santa Barbara, CA 93192

to order by phone: (800) 662-8351
www.danielpublishing.com

Also by Dolores L. Cullen—

Chaucer's Pilgrims: The Allegory

"She writes well, making difficult ideas accessible to beginners and sharing her excitement about Chaucer studies....Cullen's is a thought-provoking addition to literature on this well-studied classic."

—*Library Journal*

Have you ever wondered why Chaucer's pilgrims all arrive at dusk?

Dolores Cullen, whose ground breaking interpretations of *The Canterbury Tales* have already stirred up much controversy in academic circles, has the answer to that riddle.

Learn why there are no married couples among the pilgrims, and no children either. Learn why most of the pilgrims are men (there are only three women). Learn about the two brothers, the broad-shouldered door-crasher, the thin and easily angered one who lives in the shadows, the man who calls for water, the horseman, the warrior, and the woman whose motto is "Love conquers all."

Read *Chaucer's Pilgrims* and find out the answer to an astrological riddle that has lain dormant for six hundred years, and learn why *The Canterbury Tales* has a star-studded cast!

ISBN 1-56474-334-9
paperback $16.95

For further information or to order this book, contact
Fithian Press
Post Office Box 1525, Santa Barbara, CA 93102
to order by phone: (800) 662-8351
www.danielpublishing.com